GRAPHISCAPE
TOKYO

Published and distributed by RotoVision SA
Route Suisse 9
CH-1295 Mies
Switzerland

RotoVision SA, Sales & Production Office
Sheridan House, 112/116A Western Road
Hove BN3 1DD, UK

Tel: +44 (0)1273 72 72 68
Fax: +44 (0)1273 72 72 69
E-mail: sales@rotovision.com
www.rotovision.com

The typeface used throughout this volume is Tarzana Narrow (Emigre),
designed by Zuzana Licko, circa 1998.

10 9 8 7 6 5 4 3 2 1

ISBN 2-88046-768-3

Manufactured in China by Everbest Printing Co., Ltd.

GRAPHISCAPE
TOKYO

Ivan Vartanian Lesley A. Martin

RotoVision

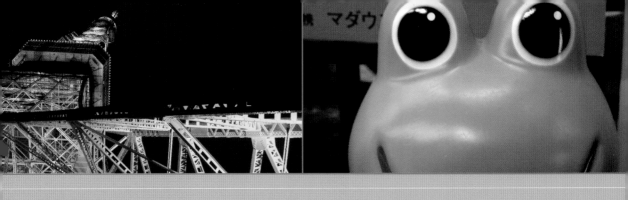

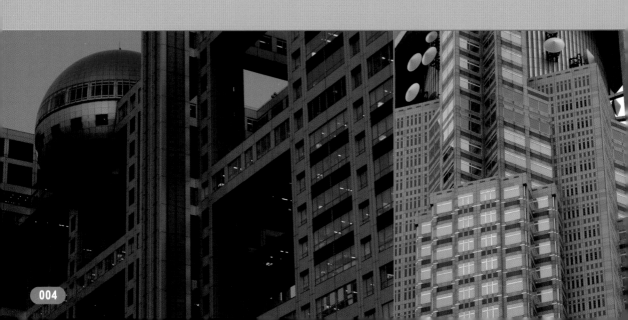

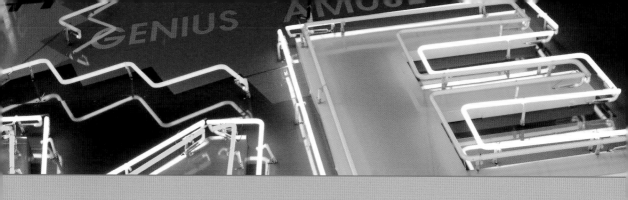

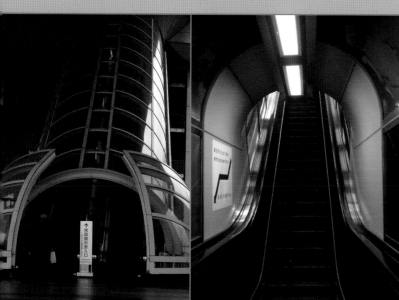

CHERRY BLOSSOM TECHNO WONDERLAND

Each volume of the GRAPHISCAPE series is a total profile of one city's graphic landscape. The unique rhythm and harmony of graphic elements that help define a city's vibe also give it its characteristic energy, setting it apart from other locales. TOKYO is the second in the series, following NEW YORK CITY.

Tokyo is a city of layers and secrets. It continues to add gigantic public spaces and to refine its internal system of signs and networks. Additionally, this city, as any other major metropolitan landscape, has had to reinvent itself in telling ways. The course of Tokyo's development has run parallel to the trend of "internationalization"—a favorite Tokyo phrase of the late twentieth century. The city has a concrete goal as challenge; to exit the customary shell of insular Japanese society. This characteristic was established early in the Meiji era (1868–1912), when the opening of Yokohama ports convulsed Tokyo with the unexpected challenges this brought to the smug insularity of feudal Japan.

Pay close attention and the city starts to unfold, revealing detail, texture, and intersecting lines that accumulate into identity. Walk through the streets of the city, catch the ever-modernizing subway to any of the main neon and

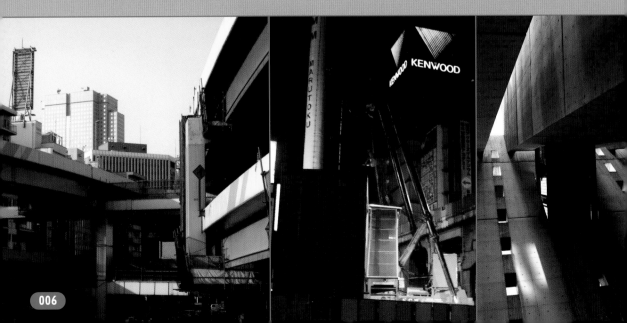

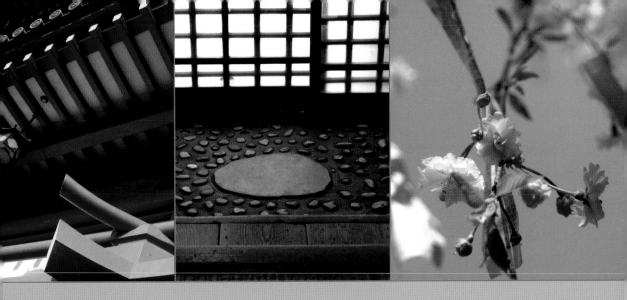

light blue LCD (liquid crystal display) centers, and you are able to glean the various layers—ancient pine and bamboo upon tin, upon steel and polished concrete. The ebb and flow of history, industry, and economy has left behind a collage of styles and artifacts that vie for your attention.

The GRAPHISCAPE series launches at a time when it is easy to suspect that globalization has done away with any large city's unique sense of self—that all city centers have become mere amusement parks with chains and franchises serving as the carnival rides. GRAPHISCAPE aims instead, to catalog a wide-ranging mosaic of elements that coalesce into uniqueness in the world's cultural capitals.

We've divided the book into five sections, presenting the over-arching themes: Neohuman City; Furry, Cuddly, Cute; Pass the Wasabi; The Empire of Signage; and Hyper Joy. In the first section, we look at the infrastructure of the city, including the various municipal systems that keep the city functioning not just in an orderly fashion, but politely as well. Here we see the contrast (or clash) that is fundamental to the Japanese aesthetic: total and utter chaos within organization. The city represents the paradox so central to the aesthetics of *wabi-sabi*; the beauty of uneven glazing on a piece of pottery; the well-worn stones on a footpath; cherry blossoms and the glistening steel of skyscrapers shooting up from a clutter of low and old buildings.

True to the reality of living in this city, most of the inspirational graphic material collected in this volume is anonymous and intended for the most practical of purposes. You will never—or at least very rarely—know who created those cute little potato chip creatures, or the cherry blossom motif that adorns cast iron sewer covers. The overall style has impact, but the creator remains anonymous. The individuals who organize the senbei into neat, geometrical grids, who craft the red lanterns to advertise fried octopus balls, and create the theatrical posters for the all-female performance troupes, are the artisans of today. This book is dedicated to them and their anonymous impact on the larger system of graphics, lifestyle, and how we experience them in the world around us.

NEOHUMAN CITY

Tokyo is huge. Even from the tallest building in the city—the Tokyo Municipal Government building in Shinjuku—you cannot see where the city ends. It is a limitless expanse of gray and a tangle of supercharged contemporary architecture rising from the midst of what looks like, at least by comparison, tin-roofed shacks. New and old are interspersed with little rhyme or reason. Tokyo is so large, it is comprised of 23 individual cities, each with its own municipal government. But what typifies most of Tokyo's aesthetic is the idealization of the modern, or rather, the new. Old structures are continually torn down, with little sentiment, for the sake of new living and working habitats to accommodate the changing needs of the Japanese economy. During the prosperous bubble, when 10,000-yen notes seemed to bloom like so many cherry blossoms, a lot of the gigantic architecture that defaces the city was initiated. Tokyo, after all, is known in the architectural community as a hotspot for new design. But "new design" doesn't necessarily make for "good design." Nonetheless, the brash collage of new materials, innovative architectural shapes, and a spate of pictographic icons, roman letters, or cute, curious creatures, are combined in a haphazard, yet stimulating manner. The Tokyo landscape has taken on a life of its own. It is a veritable map made up of layers and textures, inspiring the stuff of video games, animation, and the sets of films like *Blade Runner* and *The Matrix*.

Tokyo is also dense—a garble of exposed wires, poured concrete, and humans milling about. The balance between human scale and mass public need is constantly negotiated. Little concessions are made for anything that would make a pleasant environment. Huge systems, like the train and subway networks, are made manageable and less intimidating by easy-to-understand color coding, and manners are encouraged by public reminders and admonishments. In an attempt to deal with the almost complete lack of vegetation, images of nature are strategically posted, but this only succeeds in underscoring just how extreme Tokyo has become, built entirely from artificial materials. And yet, just when one despairs of finding any respite in the overwhelming chaos, one notices the care given to a tiny metal blossom lovingly etched on a manhole cover. Brass fixtures are polished, and it is rare to see litter in the streets. The consideration given to the safety of others bespeaks how Tokyo has learned to make life comfortable. Perhaps this jarring and antinature cityscape is exactly what is necessary to create a new aesthetic; the New Human Aesthetic is rational without being cold, is progressive without abandoning tradition completely. And the new human feels at home in Tokyo, a *neohuman* city.

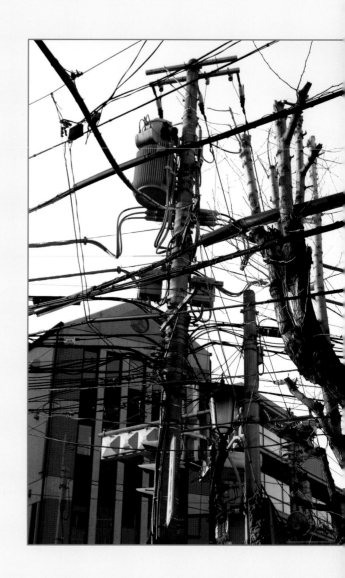

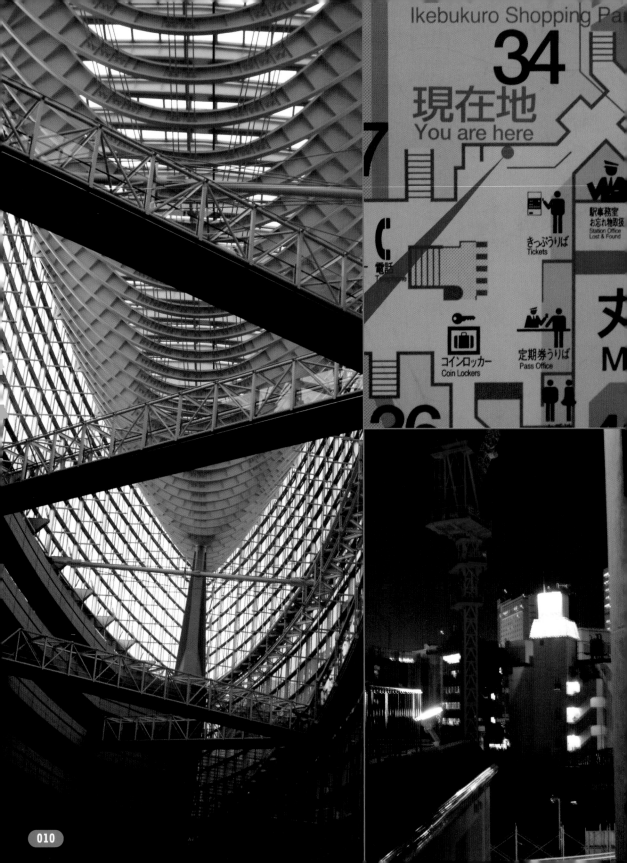

Ikebukuro Shopping Pa

34

現在地
You are here

7

℃
電話
Telephone

きっぷうりば
Tickets

駅事務室
お忘れ物取扱
Station Office
Lost & Found

コインロッカー
Coin Lockers

定期券うりば
Pass Office

丸

M

36

4

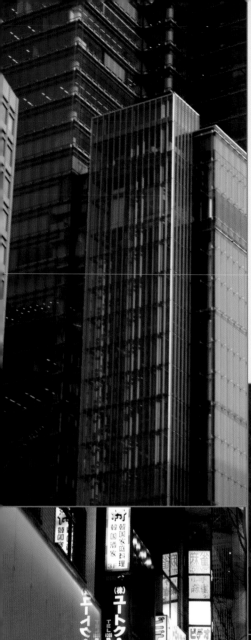

YOU ARE HERE The economic doldrums of the past few years notwithstanding, tremendous public structures have reached completion all across the city, dramatically changing the cityscape in just a couple of years. In and around Tokyo you can catch a glimpse of the "neohuman city"—a PR slogan of the late 1980s. Built on a scale to rival Brasilia, and infused with equal optimism, sleek, futuristic lines abound in the new Odaiba Bayside Park. Other architectural sites utilize the sleekest, most hi-tech and contemporary materials, angles, and lines, taking their lead from foremost Japanese architects such as Shigeru Ban or Hiroshi Nakao. You'll be excused for thinking you have stumbled aboard the Spaceship Yamamoto or onto the back lot of a science-fiction film.

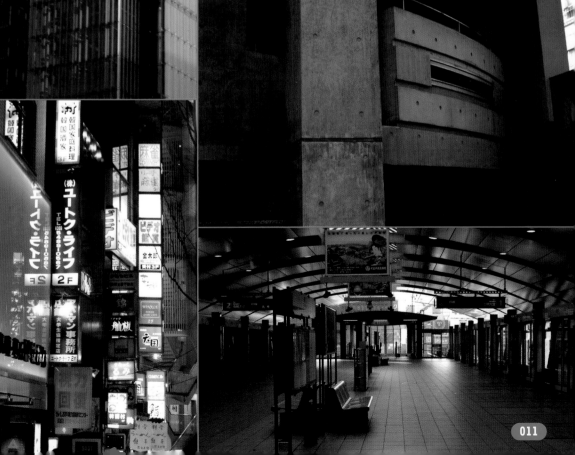

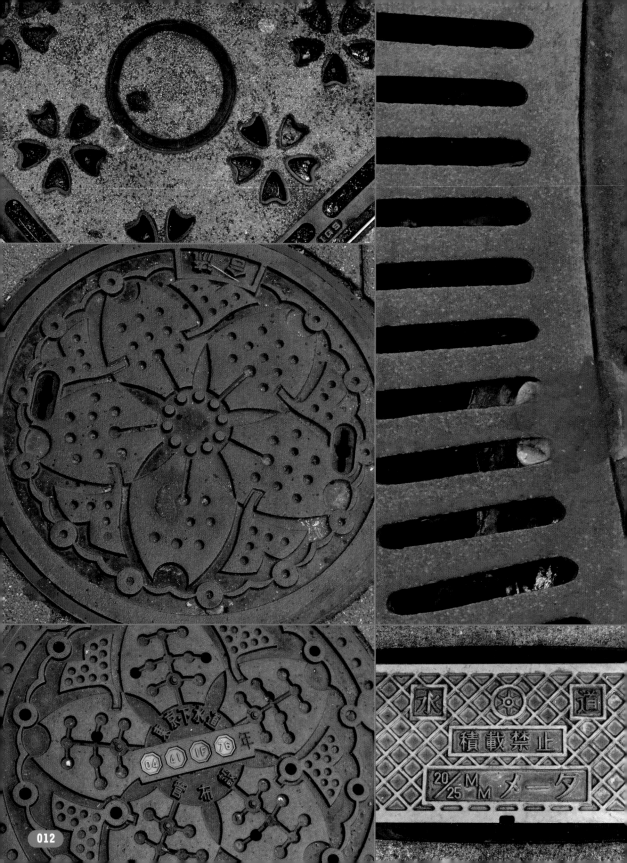

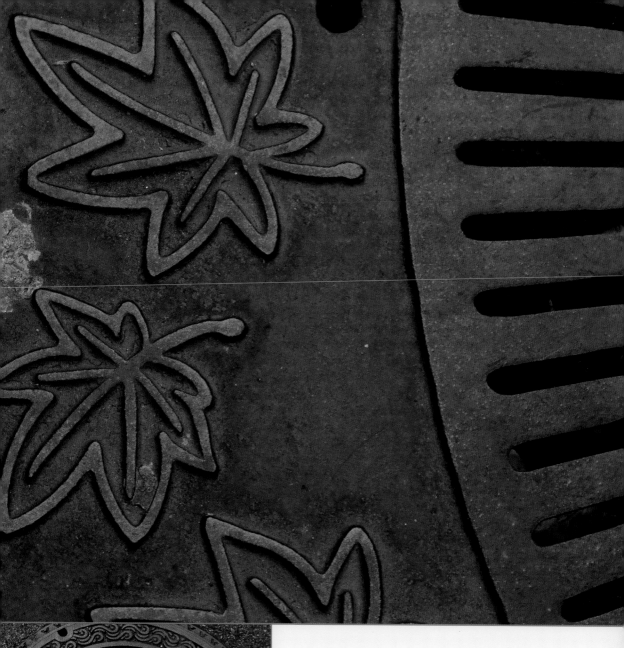

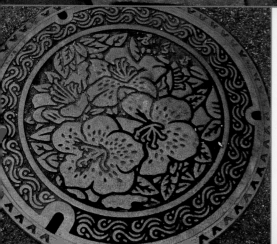

GRATE STYLE No civic detail is considered unworthy of meticulous craftsmanship and decoration. Cherry blossoms and maple leaves garnish the details of the city infrastructure. In this way, mundane sewer mains, root guards, and manhole covers are all integrated in a humanistic approach to create an enjoyable civic aesthetic.

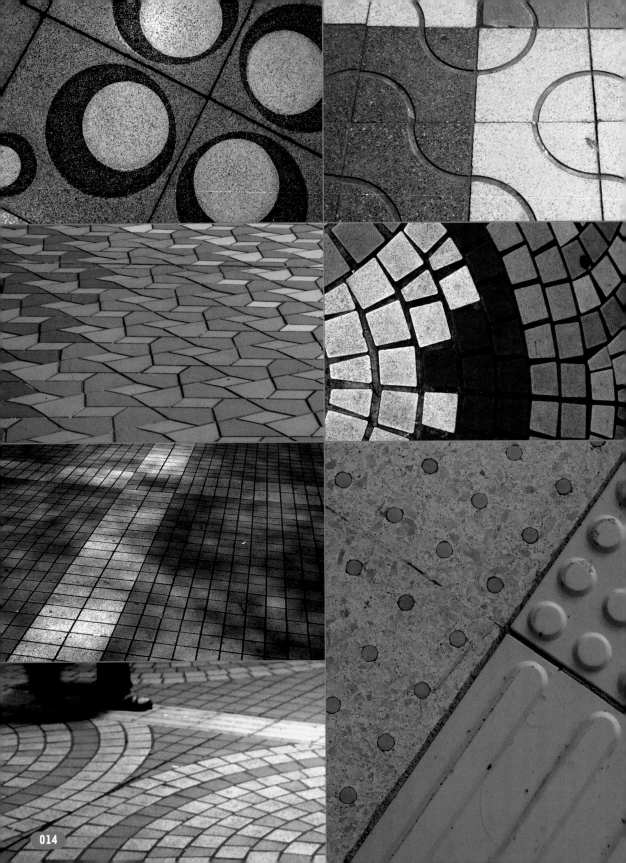

SIDEWALK SIGHTS Why make it boring when it can be delightful? As the city is ripped up and renovated, and more public and pedestrian areas are installed, the surrounding walkways have been turned into abstract, geometric patterns to keep you focused on where you are walking. As with the rest of the city, the palette tends toward soothing pastels.

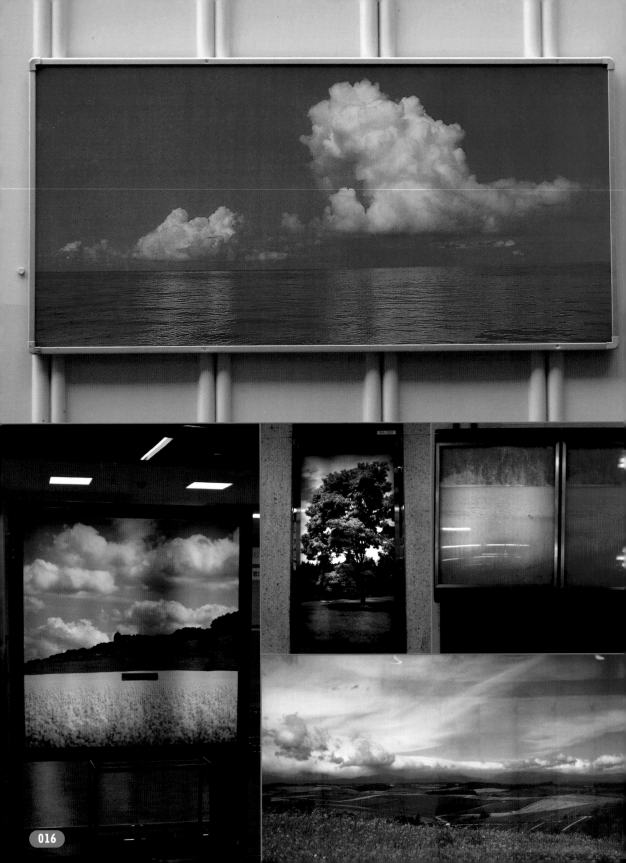

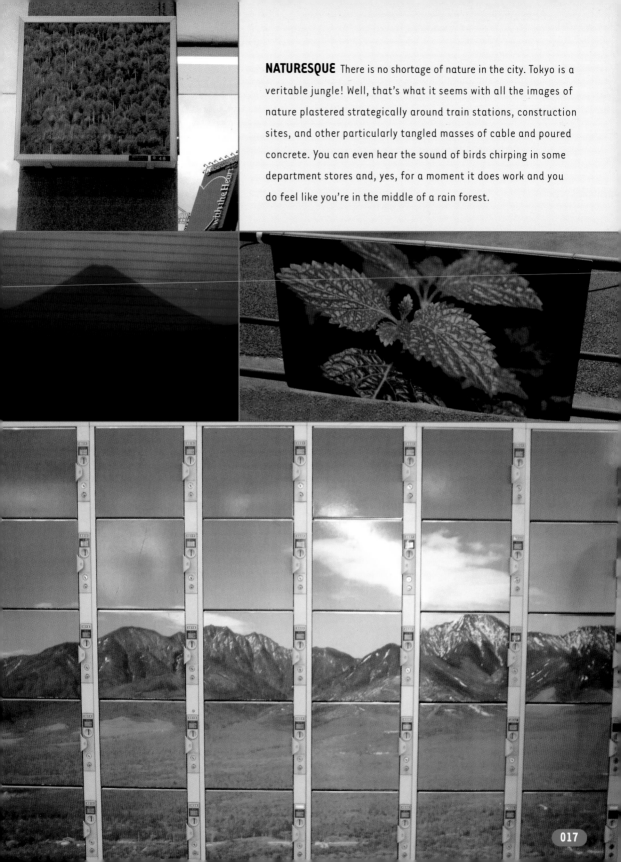

NATURESQUE There is no shortage of nature in the city. Tokyo is a veritable jungle! Well, that's what it seems with all the images of nature plastered strategically around train stations, construction sites, and other particularly tangled masses of cable and poured concrete. You can even hear the sound of birds chirping in some department stores and, yes, for a moment it does work and you do feel like you're in the middle of a rain forest.

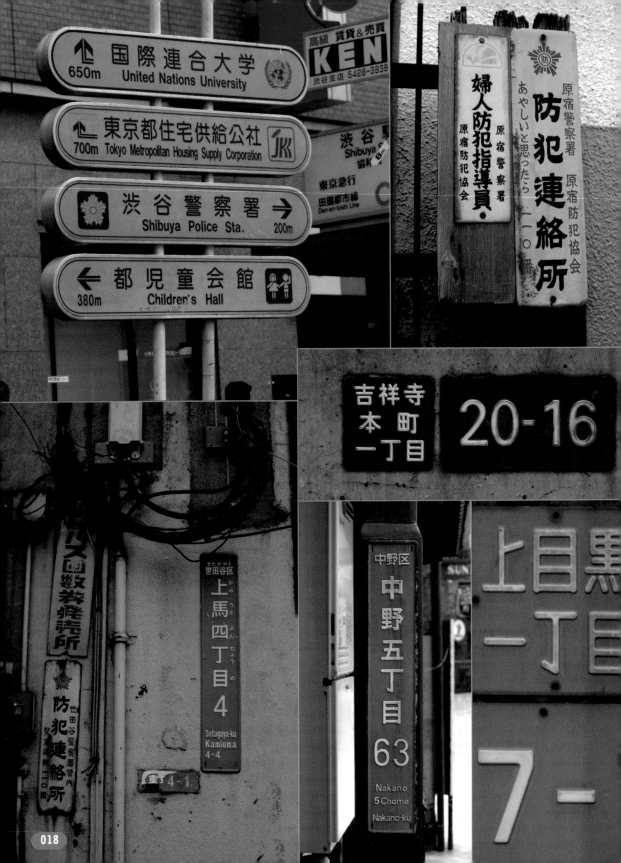

国際連合大学
650m United Nations University

東京都住宅供給公社
700m Tokyo Metropolitan Housing Supply Corporation
JKK

渋谷警察署 →
Shibuya Police Sta. 200m

← 都児童会館
380m Children's Hall

高級 賃貸&売買
KEN
渋谷支店 5428-3838

渋谷駅
Shibuya
協和

東京急行
田園都市線
Den-en-toshi Line

婦人防犯指導員・

原宿警察署
原宿防犯協会

防犯連絡所
あやしいと思ったら一一〇番

原宿警察署
原宿防犯協会

吉祥寺
本町
一丁目
20-16

防犯連絡所

世田谷区
上馬四丁目
4
Setagaya-ku
Kamiuma
4-4

4-1

中野区
中野五丁目
63
Nakano
5 Chome
Nakano-ku

上目黒
一丁目
7-

STREET SIGNS Last name first, first name last, and never the other way around! In Japanese culture, greater importance is given to a person's family name. This is part and parcel of the clear-cut hierarchy in society here. Address numbers follow in suit. Beginning first with the prefecture (*ken*), followed by the city name (*shi*), the ward within the city (*ku*), and finally, the addressee's name which is, of course, last name first. The exceptions to the rule include Tokyo itself, which is the capital (*to*). But this different order of things isn't the confusing part; it is the total lack of urban planning that sends everything into a tailspin. Without a map, it is entirely possible that you wouldn't be able to locate your destination, or even make it back the way you came. The numbering and the shape of the streets developed from the systems of organizing the old territories of Tokyo, and it is too late now to turn back. Originally, Tokyo was known as Edo and run by a feudal system. Wealthy families, or "houses," owned expanses of land that were generally sectioned off from neighbors by natural boundaries such as rivers and hills. But, as the fortunes of families turned, they sold off sections of land, halving, quartering, and so on until only small slivers remained, thus making the city blocks of Tokyo today. Most addresses have three numbers separated by hyphens. These numbers usually represent the partitions that resulted in the sectioning of that particular plot. This manner of organization has made for a lot of confusion, but even this domestic chaos provides for some comfort once you get to know a neighborhood and its myriad small byways.

通学路

文

世田谷区　　01.8

上馬A－411号

世田谷区内の
災害情報は、
FMラジオ
83.4
（エフエム世田谷）
でお知らせします。
世田谷区

地震だ 火を消せ!!

消火器

使用後の連絡先
世田谷総合支所
（5432）-1111

谷区
かみ
上馬
うま
四
よん
丁
ちょう
目
め
34

agaya-ku
miuma
34

とびだし 注意

朝日新聞
小学生新聞・中学生新聞
ASA三軒茶屋　TEL3414-6013
FAX3422-4344

↑
注意

資源・ごみ集積所
Recyclables and Garbage Collection Point
資源・ごみは区民の皆様が区の収集（回収）に出したものです。持ち去らないで下さい。

| | 収集日は
なります
ご注意 |
| Don't |

資源
新聞・雑誌類・段ボール・ガラスびん・缶
Recyclables (Newspapers, Magazines, Corrugated cardboard,
Glass bottles & Cans)
月
MON

可燃ごみ
燃やせるごみ
Combustible (Burnable) Garbage
火
TUE

不燃ごみ
燃えない・燃やすのに適さないごみ
Incombustible (Unburnable) Garbage
木
TH

粗大ごみ
Large-Sized Garbage
申込制です。　　TEL 5
世田谷区粗大ごみ受付センタ
受付時間　（月）～（土）8:00～
Application System
Call the Setagaya Large-sized Ga
URL http://www.city.setagaya.

資源とごみはそれぞれの収集曜日の朝、午前8時までに
Recyclables and garbage must be put here by 8 a.m. on the morning of th
リサイクルできる物はリサイクルルートにのせて資源として活か
●●●●●●●●「集団回収」に積極的に参加しましょう！●●

ペットボトルは、回収ボックスのあるコンビニエンスストアやスーパー、公共施
Please take the PET bottles to convenience stores, supermarkets or public facilities where there

事業系ごみは、資源を含めてすべて有料です。有料ごみ処理券を貼っ
A handling charge is imposed on all business-related garbage and
Please attach garbage disposal seals corresponding to the volu

世田谷区　世田谷清掃事務所　電話　3
City of Setagaya　SETAGAYA Waste Collection Office　TEL 3

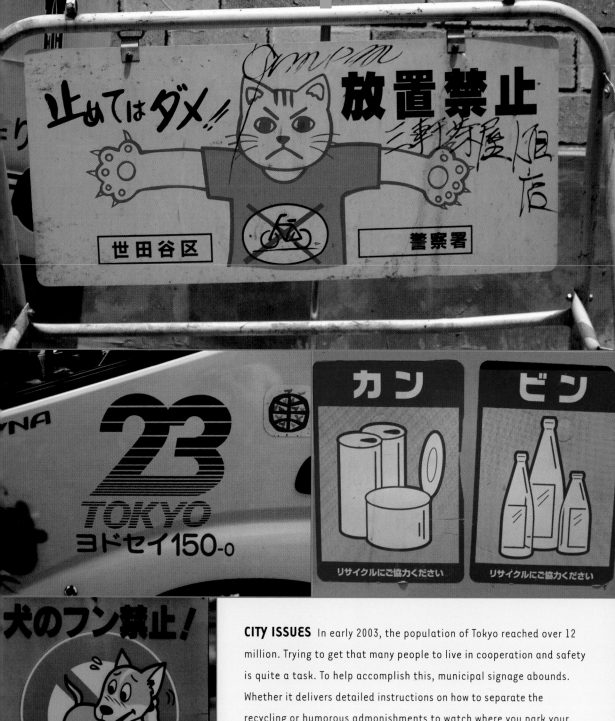

CITY ISSUES In early 2003, the population of Tokyo reached over 12 million. Trying to get that many people to live in cooperation and safety is quite a task. To help accomplish this, municipal signage abounds. Whether it delivers detailed instructions on how to separate the recycling or humorous admonishments to watch where you park your bike, a sign exists to help you figure out the best way to fit into the flow of human interactions in the big city.

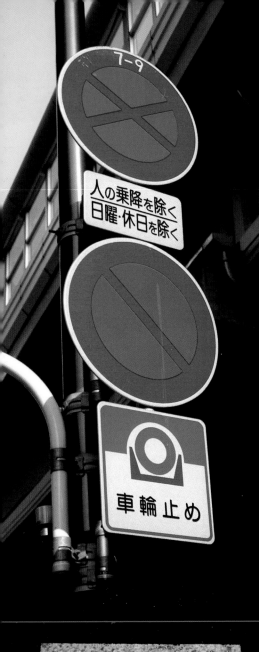

7-9

人の乗降を除く
日曜・休日を除く

車輪止め

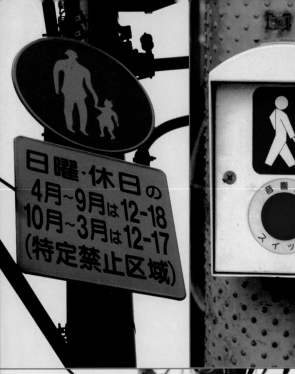

日曜・休日の
4月~9月は12-18
10月~3月は12-17
(特定禁止区域)

視覚用
スイッチ

とまれ

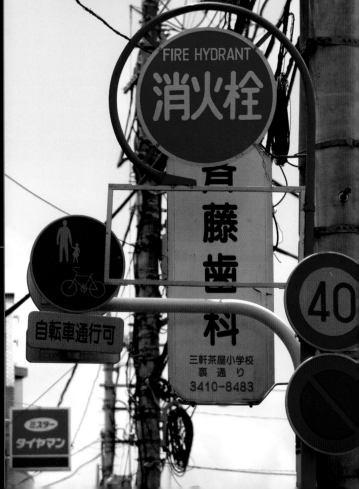

FIRE HYDRANT
消火栓

自転車通行可

齊藤歯科

三軒茶屋小学校
裏通り
3410-8483

ミスター
タイヤマン

40

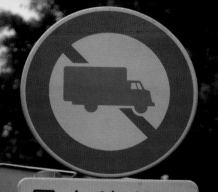

最大積載量
2t以上の貨物
居住者用車両
を除く

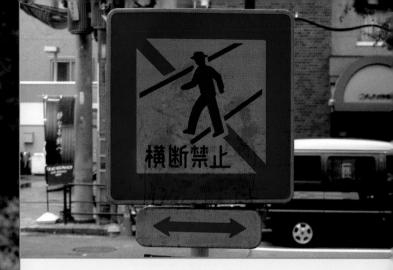

横断禁止

WALK THIS WAY The Tokyo horizon is filled with telephone and electrical wires, making it vital that the municipal signage be as distinctive and consistent as possible. The stark blue, red, and black of the signage responsible for traffic keeps the flow of cars, people, and bicycles moving in the right direction.

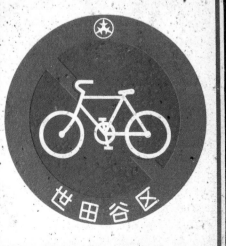

自転車・バイク
放置禁止区域

世田谷区

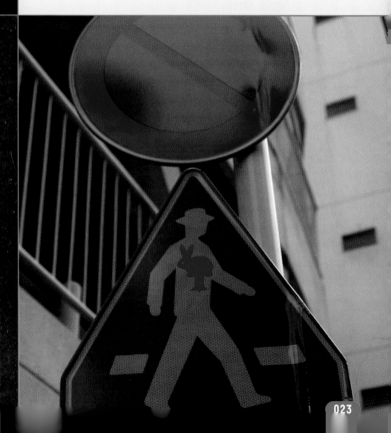

レス外
立入禁止

立入
禁止

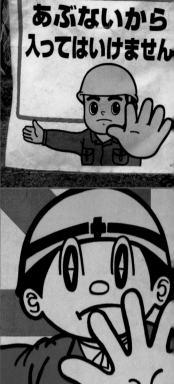
あぶないから
入ってはいけません

307-01

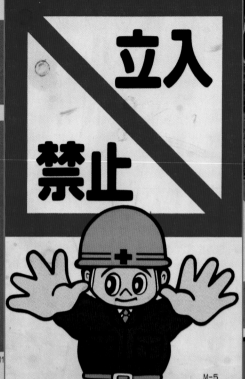

M-5

ご迷惑をお掛けして
まことにすみません

安全には特に気を付けて
作業しておりますから
しばらくの間
ご協力をお願いします

渋谷駅務区長

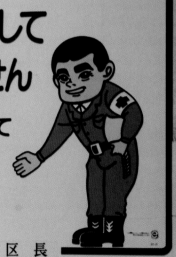

高圧
洗浄禁止

491-01103

確認・手順

配電・安全対策協議会

建築計画のお知らせ

建築物の名称	仮称　学校法人	
建築敷地の地名地番	東京都　国分寺市　泉町	
建築用途	学校	敷地面積　919.27㎡

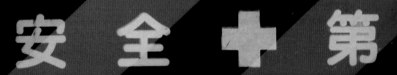

只今工事中です 何かと
ご迷惑をおかけ致しますが
安全第一で作業中ですから
しばらくの間
ご協力願います

安 全 ✚ 第 一

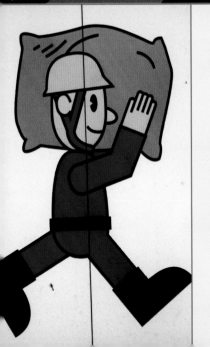

SAFETY FIRST There are few vistas of Tokyo free of construction or demolition sites. The speed with which buildings are razed and glistening glass towers erected is mind-boggling. Land development shows no signs of slowing, and various sections of the city are undergoing transformations; far from being held sacred, older edifices are considered far less comfortable than new, and a bother to maintain. Construction-site managers, sensitive to any inconvenience they may give, invariably man the sites with public safety guards who direct and forewarn pedestrian traffic, bowing politely all the while. Advisory notices, some designed by the studio of Japan's legendary progenitor of *manga*, Osamu Tetsuka, portray them bright-eyed and concerned for your safety.

KOBAN

数寄屋

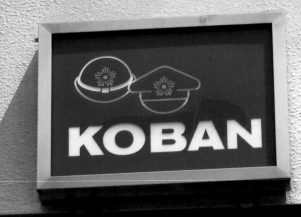

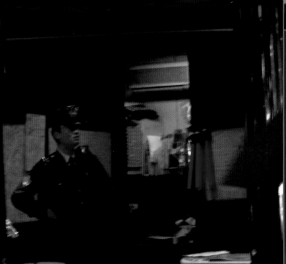

KOBAN

お願い!!

みんなのヒーロー。

愛川県警察官・事務職員募集

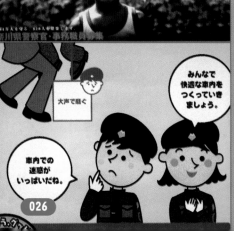

大声で聞く

みんなで
快適な車内を
つくっていき
ましょう。

車内での
迷惑が
いっぱいだね。

こども
110番の家

こども110番
てへ゛゛ん

渋谷区
安全・安心まちづくり協議会
渋谷警察署/原宿警察署/代々木警察署

許さない、不正義。

暴力団等、反社会的勢力からの不当要求は断固拒否し、
警察や暴力追放運動推進センターに相談しましょう。

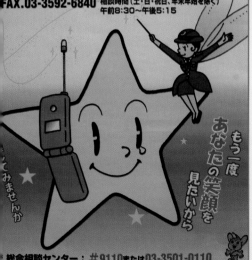

犯罪被害者
ホットライン

TEL.03-3597-7830
FAX.03-3592-6840
サア イク ナラ ナヤ ミ ゼロ
相談時間(土・日・祝日、年末年始を除く)
午前8:30〜午後5:15

もう一度
あなたの笑顔を
見たいから

てみませんか

総合相談センター：#9110または03-3501-0110
悪質商法/コンピュータ犯罪/交通問題/DV/ストーカー/少年問題/その他

けいしちょう

WE'LL NAB THOSE BADDIES! Crime fighting has never had such a benevolent look. In Tokyo, abiding by the law is simply good manners and the police, in their general presentation, offer more an appeal to civility and mutual respect than the strong arm of the law. The poster showing an officer with Tinkerbell-like wings perched on a star, for example, is advertising a hotline for reporting criminals. Peepo-kun (center: middle and bottom) is the Metropolitan Police Department's mascot. Here the *onegai* written above him requests the cooperation of Tokyo's citizens.

UNDERGROUND Red line, yellow line, green line, blue line. The maps may look like a tangle of soba noodles, but the extensive subway system of Tokyo is surprisingly friendly and easy to navigate. The lines are color coordinated and all signs are in Japanese and English. The first subway line, the Ginza, opened in 1927; there are now 12 lines which intersect with the (mostly) aboveground Japan Railway train network, and over 300 subway stations. Don't worry about losing your way—there are arrows and maps at every turn to keep you headed in the right direction. And if you feel as though you've made a wrong turn, the station masters are there to help you figure it out.

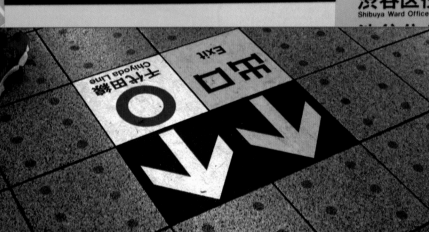

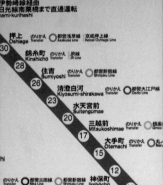

きっぷうりば ←

電車がきます

非常通報ボタン
EMERGENCY BUTTON

自動改札機を
ご利用ください

← 出口
Exit

3a
東急本店通り方面
for Tōkyū-honten-dōri
シブヤ109
Shibuya 109
東急百貨店本店
Tōkyū Dept. Store Main Store

JR線
J.R. Lines

銀座線
Ginza Line

東横線
Tōyoko Line

井の頭線
Inokashira Line

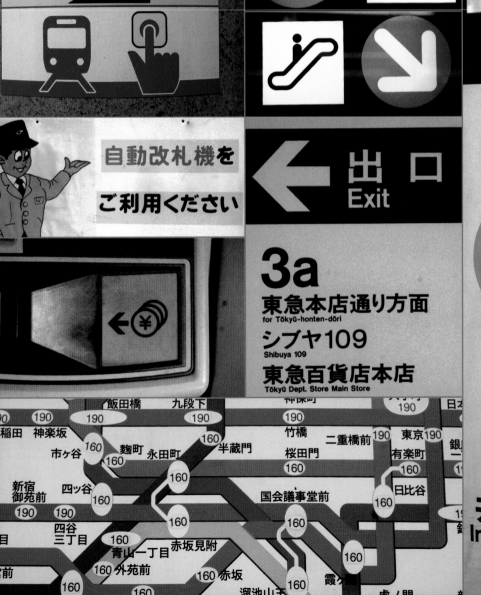

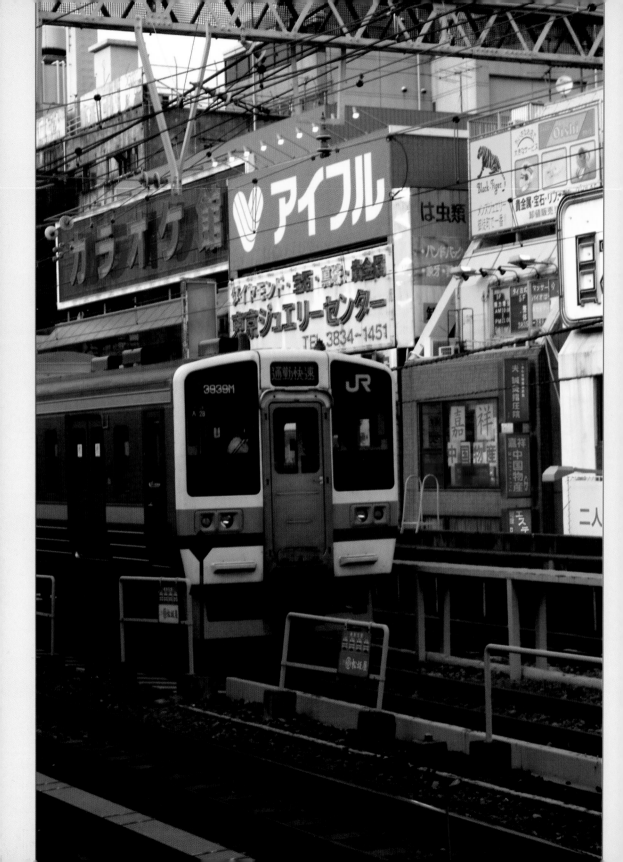

JAPAN RAILWAY Over the past decade, JR East (東日本), the company that runs the train system in eastern Japan, has been slowly privatizing. The self-proclaimed goal of JR East is to become a "trusted lifestyle services creating group." Whatever this means exactly, JR is dedicated to making it easy for you to navigate Tokyo and its immediate surrounds. The service is impeccable and, despite the steady stream of millions who use the trains on a daily basis, the cars are superbly maintained and the timetables strictly adhered to. It is said that office workers spend about two hours a day commuting, and many work until the last train stops running, which is around midnight. They do run like clockwork, so much so that an arrival as little as 30 seconds late warrants an apology to the passengers. But pay attention to the signs encouraging you to resist the temptation to run for a train!

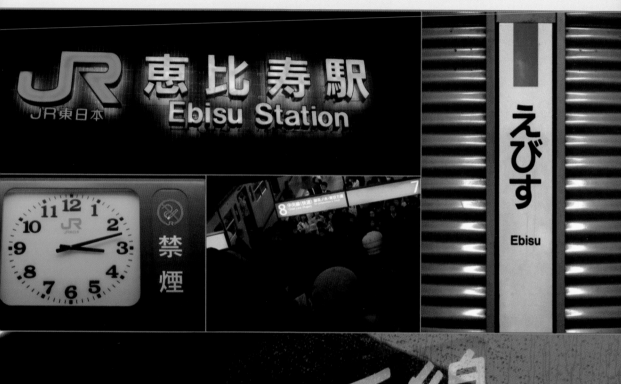

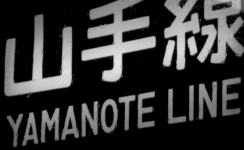

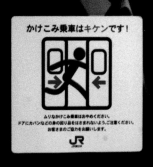

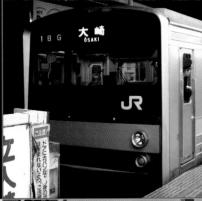

Customer Service	Shinjuku Ward Office	Kōshū-Kaidō
はとバス Hato Bus	スタジオアルタ Studio Alta	ルミネ2 LUMINE2
タクシー Taxi	新宿コマ劇場 Shinjuku Koma Theater	ウインズ Wins Shinjuku
東口交番 Higashiguchi Police Box	新宿文化センター Shinjuku Bunka Center	南口方 for South
歌舞伎町方面 for Kabukichō	厚生年金会館 Kōseinenkin Kaikan	みどり Ticket Of
靖国通り Yasukuni-dōri Ave.	マイシティ MYCITY	タク Taxi
新宿通り Shinjuku-dōri Ave.		甲州街道 Kōshū-Kaidō
		高島屋タイム Takashimaya Tim
西口方面 for West Exit	東京都庁 Tōkyō Metropolitan Government Office	JR東日 East Japan Railway Co
みどりの窓口 Ticket Office	新宿郵便局 Shinjuku Post Office	中央西 for Central
バス Bus	新宿警察署 Shinjuku Police Station	
タクシー Taxi	東京医科大学病院 Tōkyō Medical University Hospital	中央西 Chūō Hi
西口交番 Nishiguchi Police Box		
高層ビル街方面 for Skyscraper District	東京女子医大病院 Tōkyō Woman's Medical College Hospital	

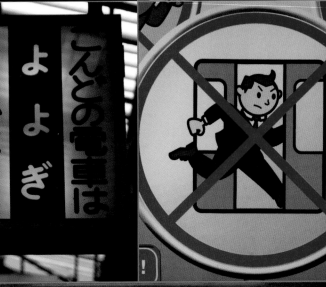

ハチ公口 Hachikō Exit 八公出口 하치코 출구	銀座線 Ginza Line	ハチ公プ Hachikō Pla
	井の頭線 Inokashira Line	

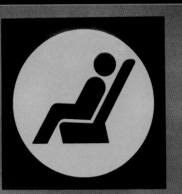

みどりの窓口
指定席券売機

営業時間 5:30〜23:00

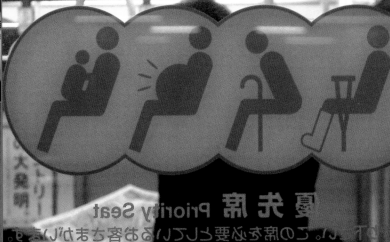

夏先席 Priority Seat

新宿駅長

新 宿

山区

しんじゅく

Yoyogi · Shinjuku · Shin-Ōkubo

新大久保 · Shin-Ōkubo

13 山手線 Yamanote Line · 池袋・上野方面 for Ikebukuro & Ueno

◀ 14番線 発車時刻

各駅停車 17:56 中 野

各駅停車 18:01 中 野

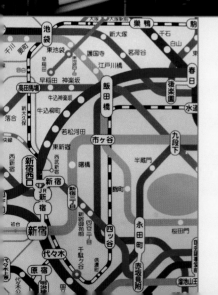

SHINJUKU STATION With about 60 exits, 14 platforms, and connections, Shinjuku exemplifies the utilitarian nature of its signs. The morning commute is formidable. Around half a million passengers move along platforms and are ushered (or pushed in most cases) into jam-packed train cars with the help of white-gloved station attendants who always seem convinced that there's room for 10 more passengers in every car. And that's just a couple of hours in the morning. The situation is not only true of Shinjuku station but nearly all stations in Tokyo.

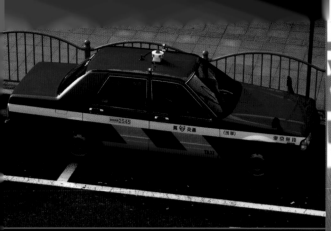

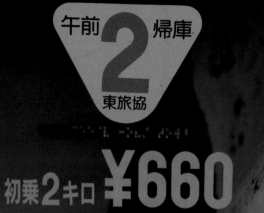

午前 帰庫
2
東旅協

初乗2キロ **¥660**

WIDE NETWORK

NICE TAXI

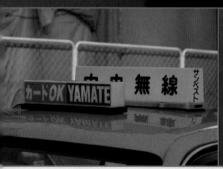

カードOK YAMATE 無線 サンベスト

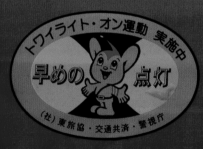

トワイライト・オン運動 実施中

早めの 点灯

(社)東旅協・交通共済・警視庁

カードOK 2-32 一越 チェッカー

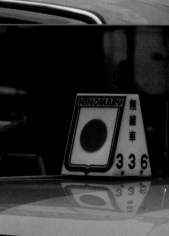

HINOMARU 無線車 336

NICE TAXI There's no standardized color or design scheme for the fiercely independent taxi squadrons of Tokyo. Each company or independent contractor proudly displays their own crest and color scheme. Even the lights come in different shapes and patterns according to the driver's allegiance. And don't try to open that door on your own; the automatic doors swing open, saving you all the hassle. What a nice taxi!

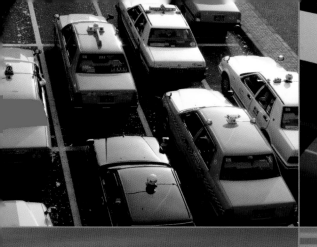

大日本 交通

TAXI

（荻窪）

自動ドア
AUTO DOOR

中央 367 無線 足立

東京無線 東京無線

km 606

GROUP

FURRY, CUDDLY, CUTE

The prevalence of cartoon characters in Japan has few rivals. Adorable faces with superhumanly large eyes beam out from restaurant menus, traffic alert signs, construction sites, power-surge warnings, convenience store windows, hospital admittance rooms, stationery shops, and on, and on. In place of simple and expressionless stick figures and utility graphics, they give a rich depth of emotion and character. Leaders of the pack are Osamu Tetsuka's timeless creation Atom Boy, and Sanrio's legendary empress of licensed goods Hello Kitty (known and adored in Japan as *Kitty-chan*, meaning "Kitty dear"). Though these characters have their origins in material intended primarily for children, they have garnered trust and appeal that cuts across all age-groups. In fact, such super-characters have an awesome marketability. Apart from a slew of merchandise, Atom Boy is also the mascot for a number of different services, including a home-security company. Similarly, *Kitty-chan* has expanded beyond the world of children's stationery and is now an integral part of the corporate identity of a major Japanese bank. So, what to Western eyes may be dismissed as cute cartoon characters for children are, in fact, highly strategic tools of commerce. The cuteness belies the sophistication of this vibrant and powerful character culture. Clear outlines give form and definition to simple shapes and distinguish intricate color use.

The Japanese public is a seasoned interpreter of character style, due not only to the pictographic nature of its script and the frequent use of cute drawings to convey important information, but also to the extraordinary popularity of *manga* (comic books) with all age-groups. The complexity and jam-packed density of graphic composition in Japan would make a seasoned comic book reader in the West a little dizzy. In Japan, however, a flurry of information (both visual and textual), tightly organized to maximize the detail, is a given. In this sense, the graphiscape of Tokyo operates on a different magnitude. Apart from the overbearing signs filling up the visual plane, the attention to detail can pull you into another universe. While you wait for the light to change, you may notice a small flyer advertising shiastu or a nearby dental clinic. Even these will include some characters. So heavy is the onslaught of cute and friendly characters that they, along with their environs, create a cacophony of sights and sounds that place you in their world. After a while, you might even start to understand just what it is behind that vacant Hello Kitty gaze.

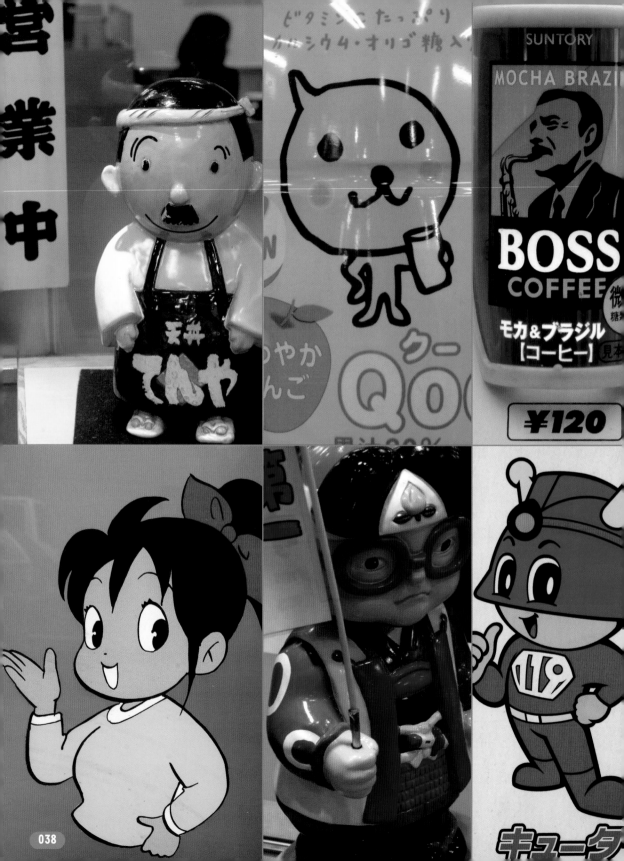

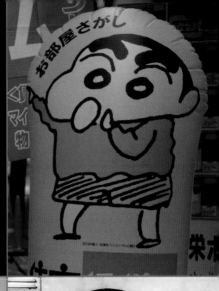

MASCOTS Whether for courier delivery service, English language instruction, driving schools, or dental clinics, there is a plethora of characters created for corporate identity. The characters are used across the board in print ads and television spots, and in promotional items such as key chains and mobile phone straps. You may not care about the business itself, but how can you say no to that cute little face with the oh-so-big eyes!

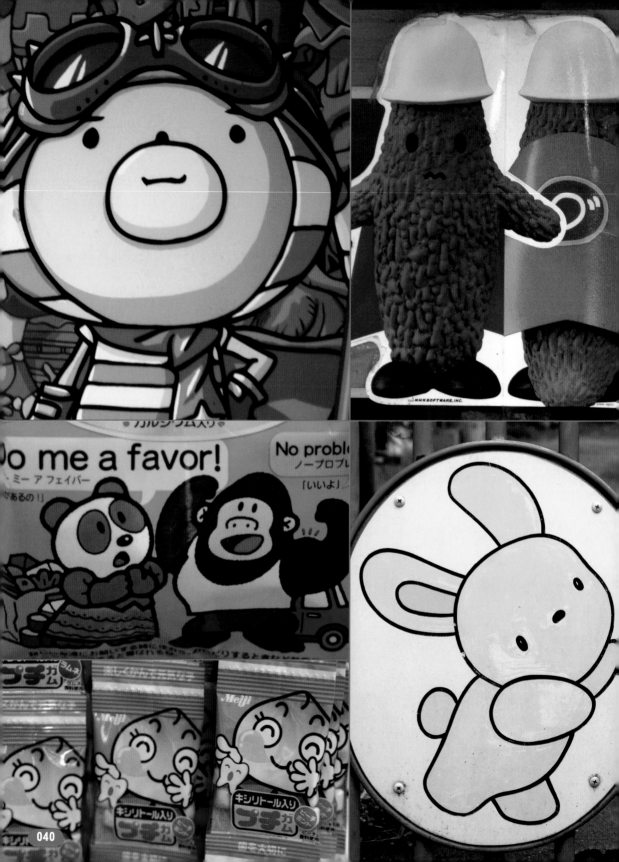

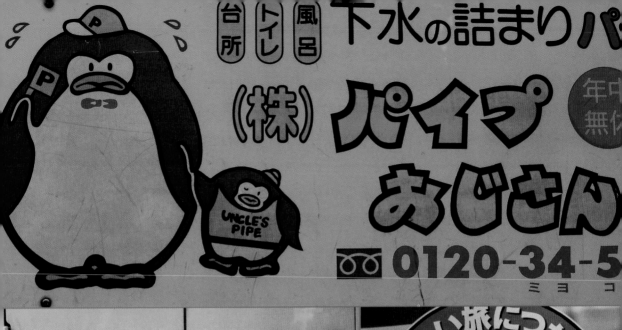

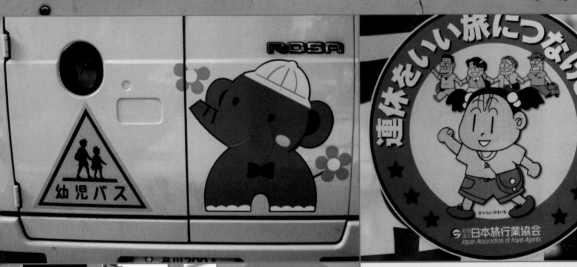

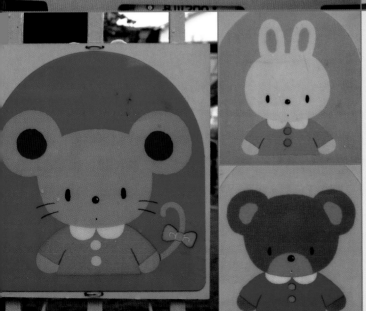

IT'S A SMALL WORLD There is a clear distinction between the style in which characters for children and adults are drawn. Apart from the smaller overall proportions, the eyes set the two apart. Those meant for children have simple Orphan Annie dots whereas complex sets of interlocked circles are used for "adult" characters.

041

CUTE ENOUGH TO EAT Japan's equivalent to Bacchus, Greek mythology's god of wine, is the ever-grimacing Ebisu-sama. He's the pudgy guy here with a fish under one arm and a fishing rod in the other hand. His fat earlobes are the traditional symbol of prosperity and abundance. The playful and inviting pig above is, as you've probably guessed, the mascot for a restaurant specializing in pork cutlets. There is no shortage of eating establishments and their appetite-inducing graphics in Tokyo. Viva Ebisu!

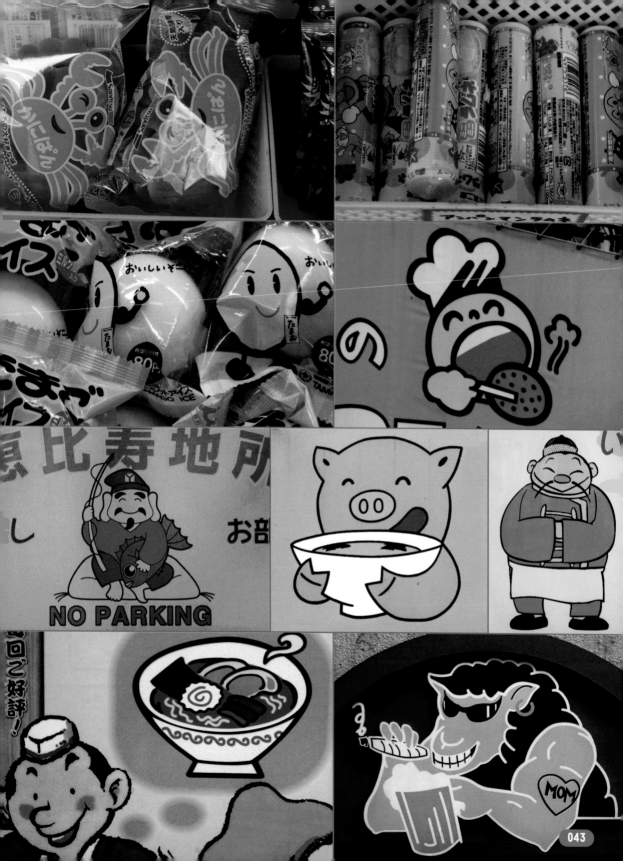

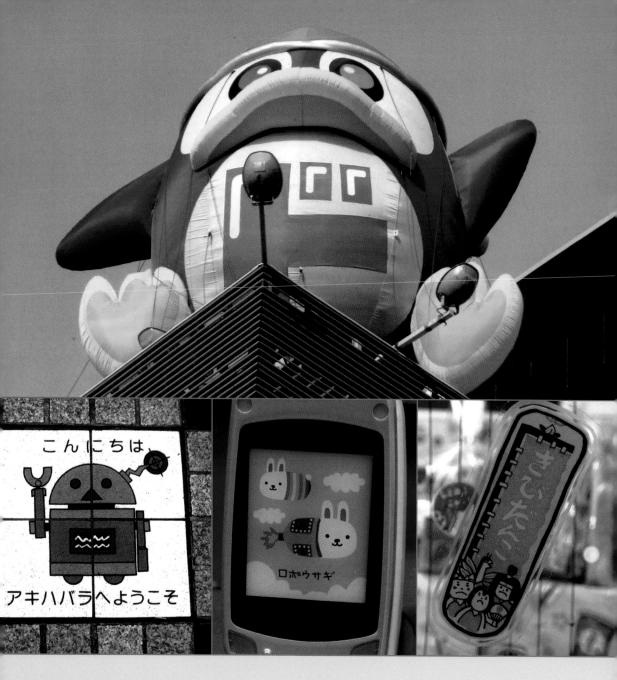

CHARACTER CULTURE Cuties, cuties everywhere. The ubiquitousness of characters in the graphiscape of Tokyo cannot be overstated. From cultural banners to the roofs of buildings, to the screen of your sleek, cute, cell phone. The cold, cruel world of work, tiny apartment, and overpacked subway is made so much more bearable when you know your friends will greet you wherever you turn.

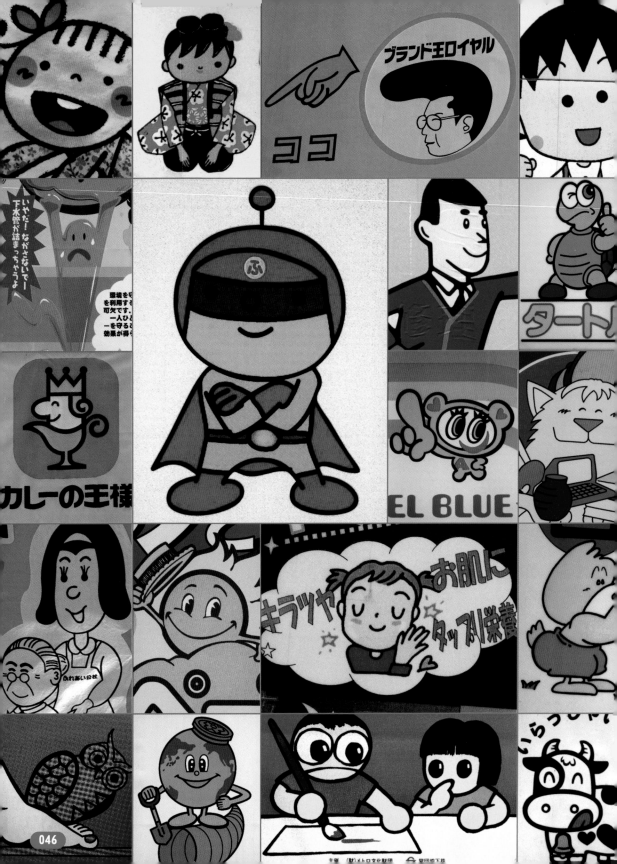

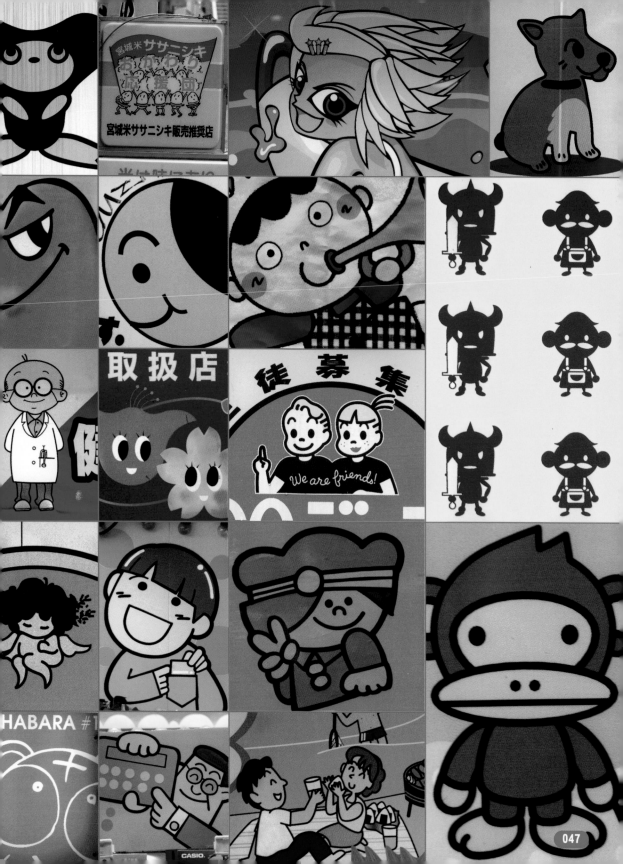

047

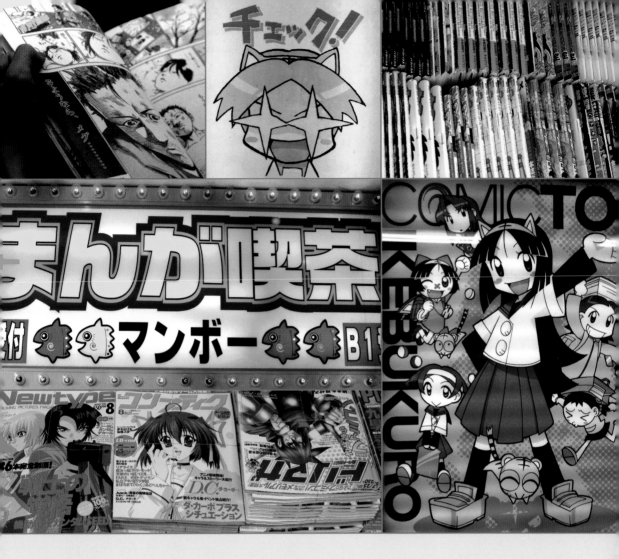

MANGA MADNESS *Manga* (Japanese comic books) are highly different from their mainstream Western counterparts in form, style, theme, and market. Readership isn't limited to young men and boys; there are *manga* written for just about every segment of society. And the themes aren't limited to action or macabre stories. Along with faraway universes and heroic battles there are stories of office melodramas—an annoying section manager with too much nose hair is pitted against a demure OL (office lady). The adventures and intrigue prevalent in most Western comics are replaced with more mundane stories: love dramas, childrearing anxieties, care for convalescent parents, et cetera. There are *manga* devoted to specific hobbies, though perhaps "hobby" isn't the right word when it verges on the obsessive. In Japan such extreme hobby enthusiasts are called otaku. There are *manga* devoted to mahjongg players, go players, and even to *pachinko*. There are, of course, typical action *manga* too. Inclusive of all books, magazines, and newspapers, *manga* comprises 40 percent of published material in Japan.

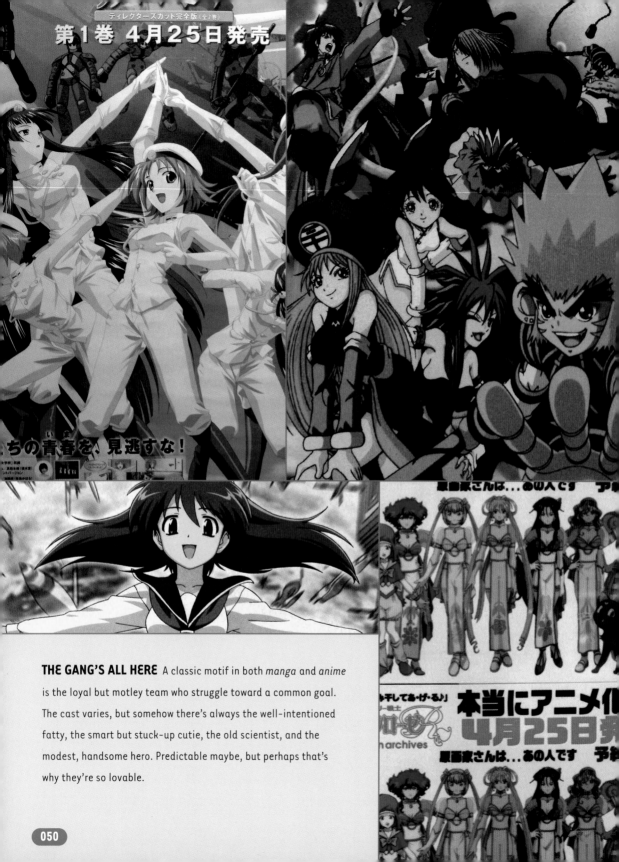

THE GANG'S ALL HERE A classic motif in both *manga* and *anime* is the loyal but motley team who struggle toward a common goal. The cast varies, but somehow there's always the well-intentioned fatty, the smart but stuck-up cutie, the old scientist, and the modest, handsome hero. Predictable maybe, but perhaps that's why they're so lovable.

PASS THE WASABI

Even the most experienced connoisseur of Japanese cuisine may be thrown when confronted with the baleful eye of a twitching fish staring them down while the remnants of its sliced-up self is used as a serving tray. So fresh it's moving! But use of materials and flavor is just one aspect of a Japanese meal. The traditional meal is a wholly aesthetic experience that begins with the proprietor's greeting when you enter the *genkan* (entranceway) through to the very bowls and cups used throughout the meal. All these elements contribute to the overall flavor of the meal. What best epitomizes the Japanese aesthetic for pottery is not the pristine bowl with immaculate glaze but rather, the well-used earthenware that shows its age. And considering how Japanese food is comprised of a myriad of small dishes, the harmony of the bowls, plates, and cups is key.

However, modern life makes more traditional Japanese cuisine a second choice. After all, who's going to wash all those bowls? Instead, fast food and snack food are the *tsunami* of the future. Enter the all-beef patty and microwave dinner. But the old classics have also been updated for a demanding public on the go. *Kaitenzushi* (conveyor-belt sushi) is one new national fast food. So fast, in fact, there are even stern admonishments placed strategically before eaters: Eat at least seven items! No talking! No reading! Finish eating within 20 minutes! With some popular establishments, such as the *Tsukiji Honten Kaitenzushi*, the line snakes around the block on busy days. So, yes, there is no time for idle chatter. The new Western cuisine incorporates new methods for old ingredients as well as new adventurous dishes with imported delicacies. As the hamburger jostles for a place at the table next to rice balls and dried fish flakes, it's not just taste buds being awakened—a new aesthetic is being born as well. Fast-food chains have sprung up and even the old classics have adapted to the new demands of a hyper-paced city. Still, some things never change; the extensive use of corn persists (it's in nearly everything!), along with proper manners. Every meal begins with a humble *Itadakimasu* and ends with an appreciative *Gochisosamadeshita*.

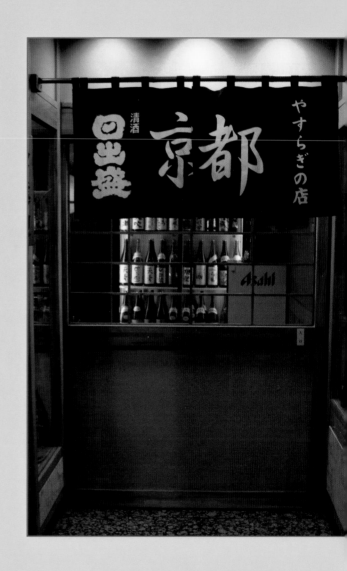

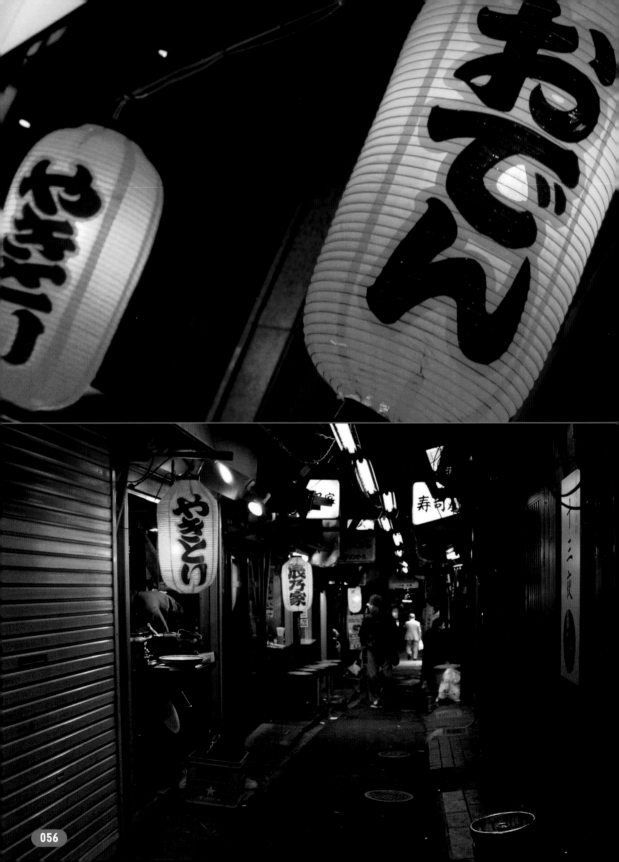

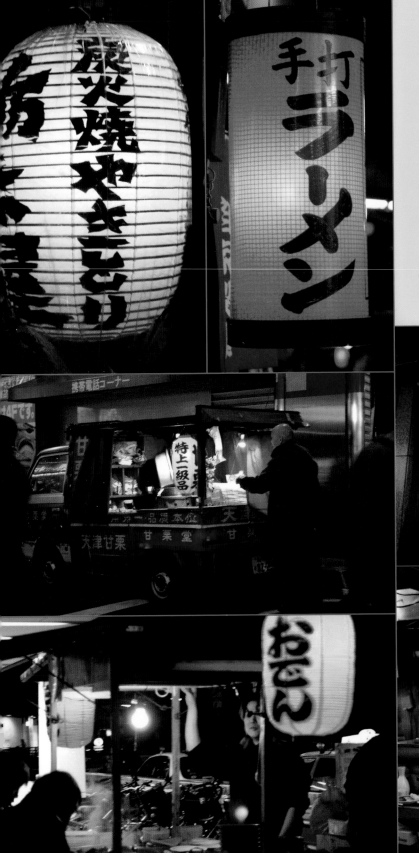

AKACHOCHIN These red lanterns are the culinary equivalent of the ubiquitous paper lanterns used in festivals and gardens. If you're hungry and can't figure out what's what, duck into any restaurant adorned with these welcoming decorations; they advertise the specialty of the house. You're sure to find *ramen, yakitori, okonomi-yaki,* or some other kind of delicious, basic Japanese pub food.

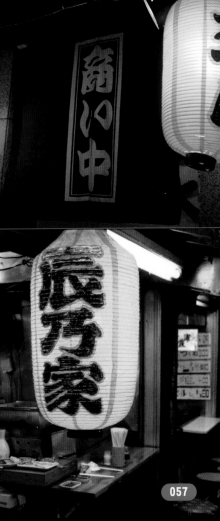

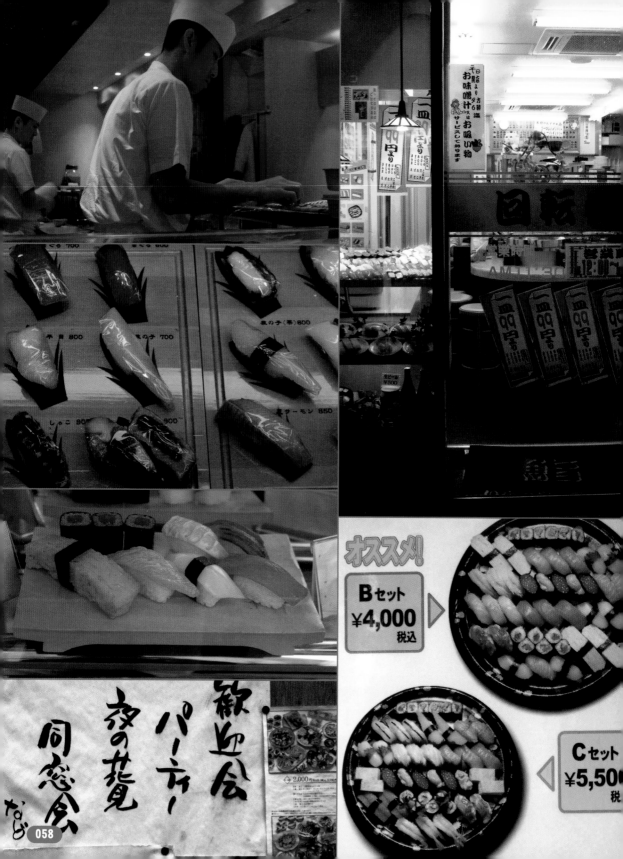

オススメ!

Bセット
¥4,000
税込

Cセット
¥5,500
税

すしやの 魚がし 活魚料理

板前迅速！ 中目黒店

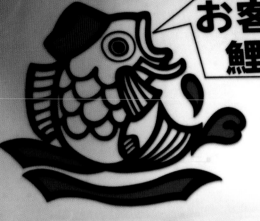

nakameguro

お客様 鯉鯉

大海老塩焼

SUSHIYA Sushi has become widely known as Japan's greatest contribution to international cuisine. The ability of a master sushi chef to take a monstrous fish and turn it into a delicate, extraordinarily stylized morsel is reflected in every small attention paid to presentation during a Japanese meal. From the entrance signs to the plate on which a *maki-mono* is served, every step toward a full stomach is an opportunity for an aesthetic experience. And each is begun with "*Itadakimasu!*" Meaning, "I humbly receive it," this phrase is the equivalent of *bon appétit*. When ordering at a *kaitenzushi*, you may notice that the lingo used by sushi chefs has its own character and can sound like a secret code. Within the trade, sushi, for example, is said with the mora in reverse: *shi-su*.

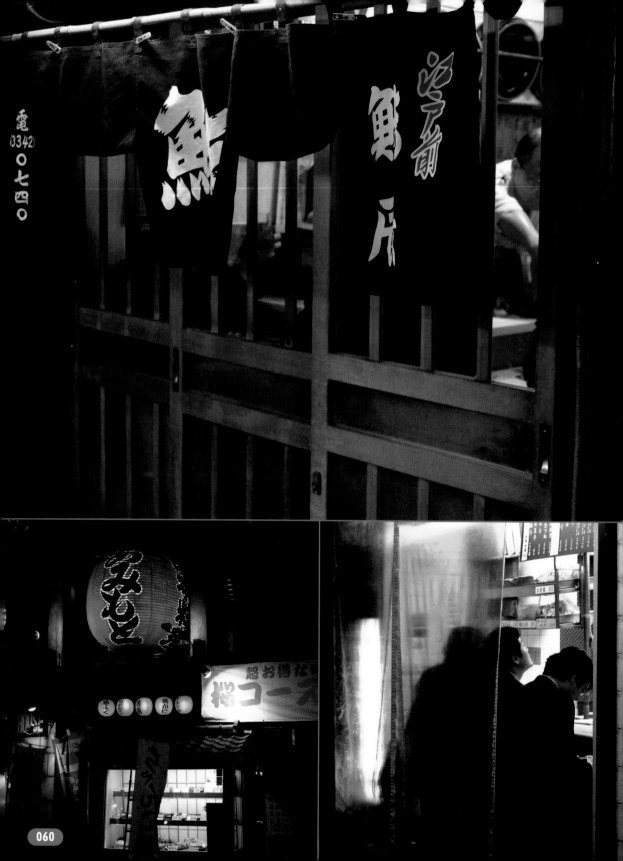

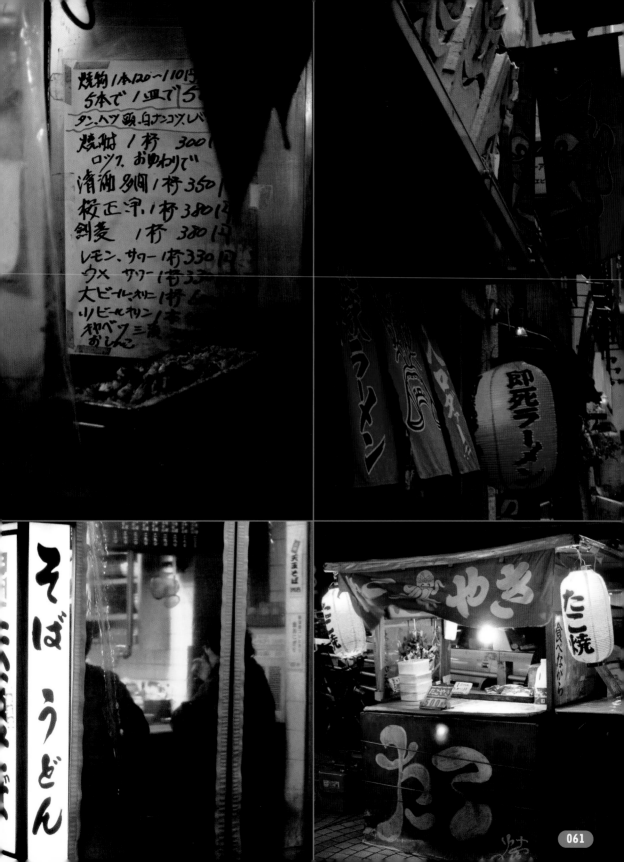

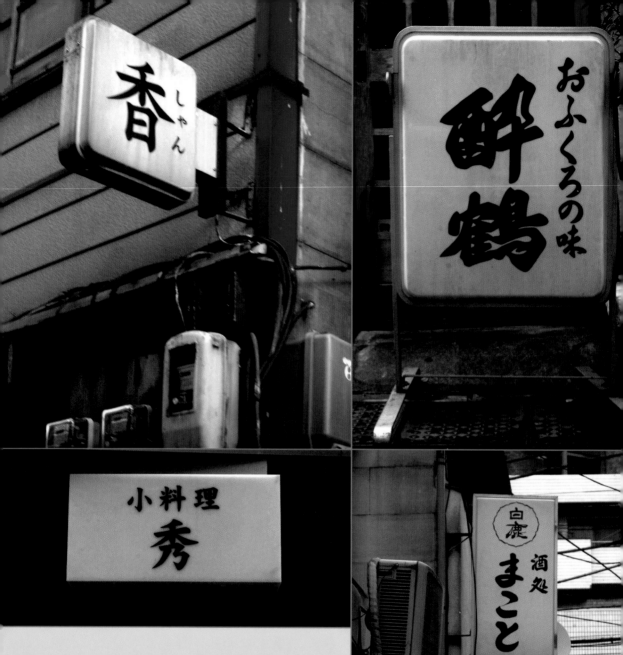

WHITE SIGNS These demure signs are generally free-standing plastic entities, illuminated from within. At night, in the winding alleys, they become beacons, guiding you to stomach-warming fare. Clear, basic, and highly functional, in the visual chaos of neighborhood drugstores, flashing traffic lights, and garish neon, these plain-jane signs stand out.

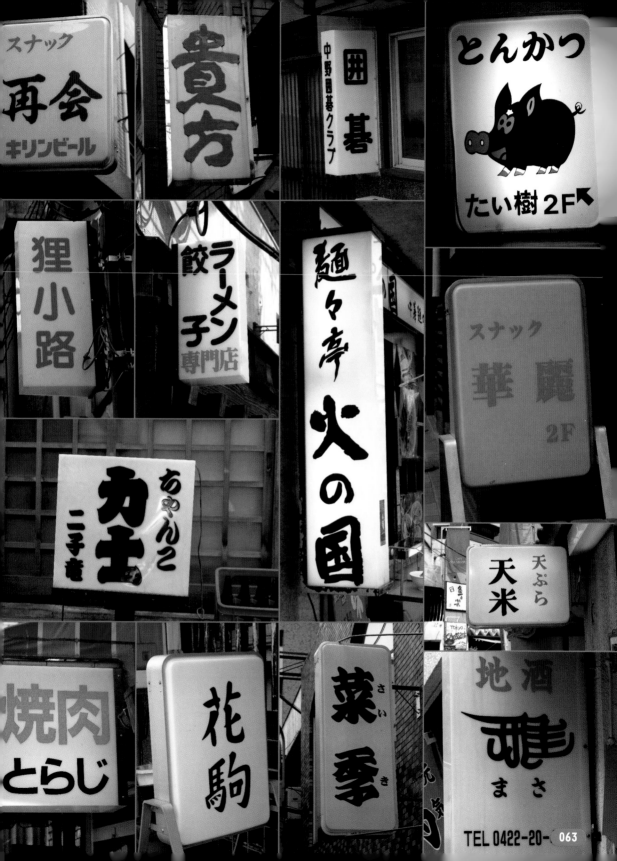

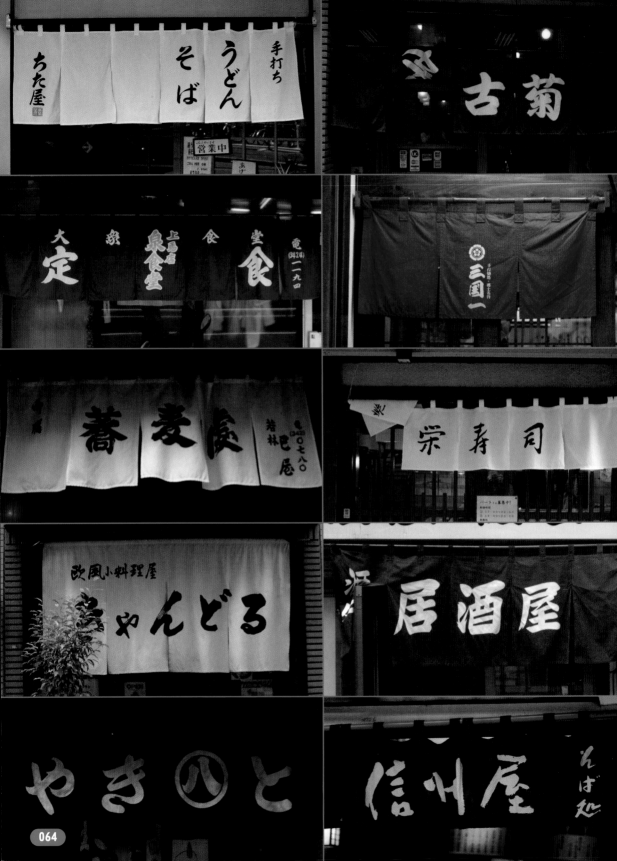

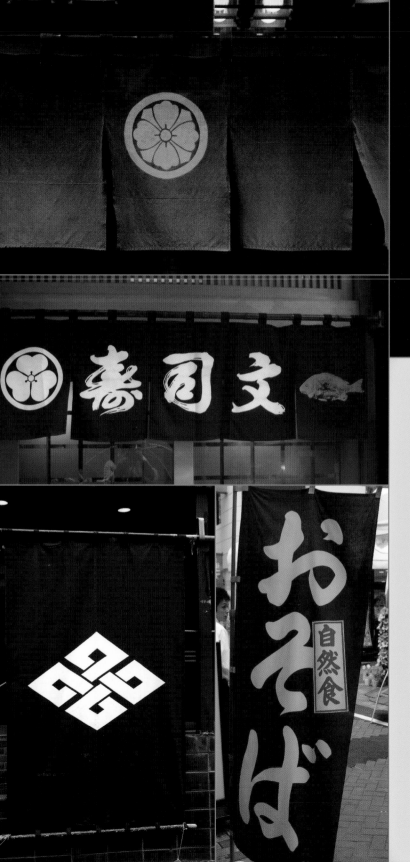

源八

NOREN *"Irrashai!"* Another typical greeting which means "welcome!" When you enter any restaurant or store, expect a chorus of greetings from the waitress, the bus boys, the busy chef, and even by means of the *noren*. Available in all shapes and sizes, but traditionally made of hemp or other tough fabric, *noren* are hung at the entrance to mark the division between exterior and interior, and they cause one to bow ever so slightly when stepping through. The drawings and lettering on each spell out the shop's name or the specialty available within.

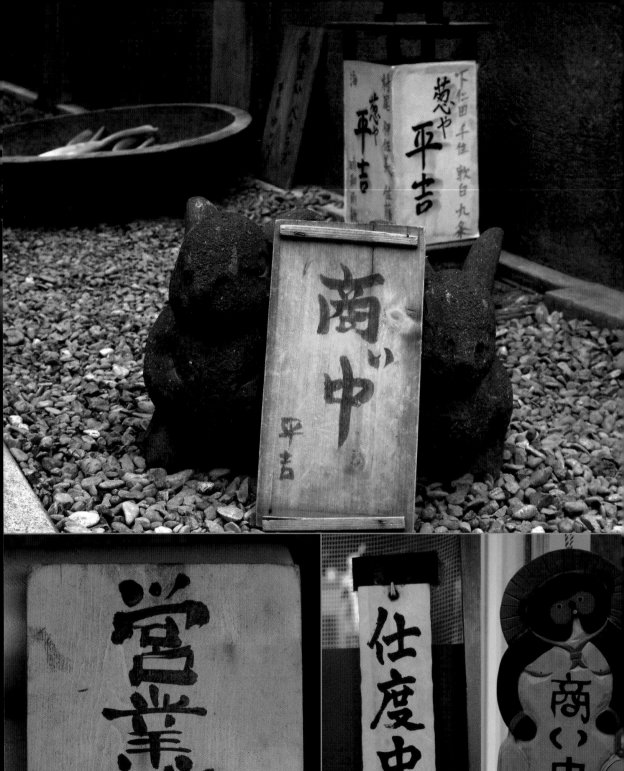

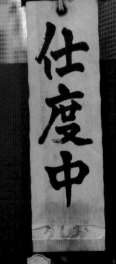

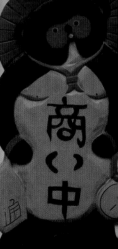

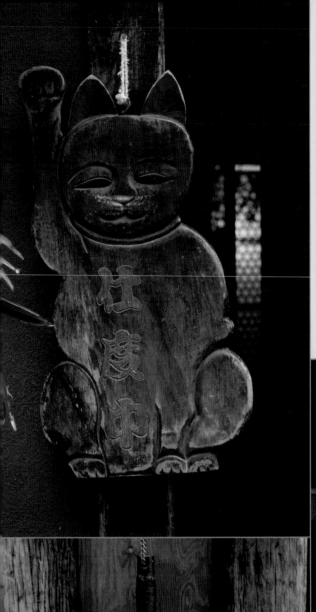

EIGYO-CHU The wooden placard placed outside an eating establishment indicates whether it is open for business. The two standard phrases, "*eigyo-chu,*" meaning "open for business," and "*junbi-chu,*" meaning "in preparation," have several variations. These can express the character of the establishment, one of the most colorful examples being "*yatteiru-zo!*" meaning, "Yeah! We're open, man!" Naturally, this intentional break with formality is usually found in restaurants that cater to a younger clientele.

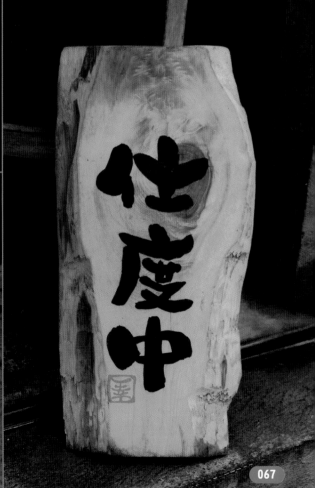

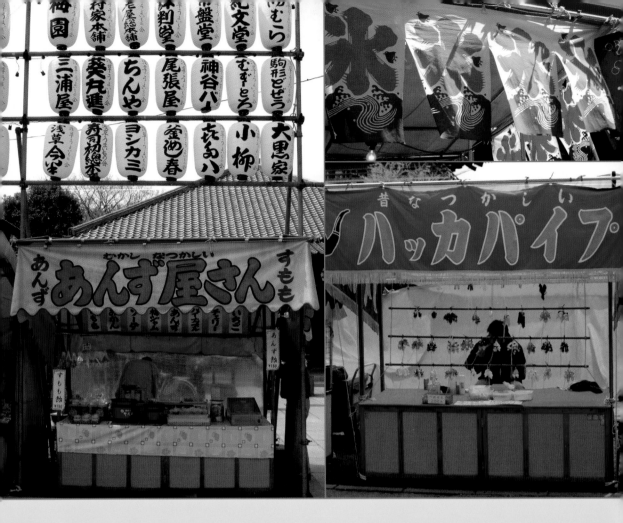

FESTIVAL FOOD Every neighborhood temple or shrine plays host to local festival-goers on a fairly regular basis. On these occasions, food vendors will set up their goods in brightly colored stalls. Is it possible that the bright neon pinks and rich mustard yellows create mysterious cravings for *yakisoba* (stir-fried noodles) and *taco-yaki* (octopus balls)? *Maneki Neko*, the welcoming good-luck cats pictured right, with their raised paws, beckon potential customers, enticing them to take a closer look. This congenial kitty is a staple good-luck charm for shop owners and traders of all kinds, symbolizing prosperity and good business.

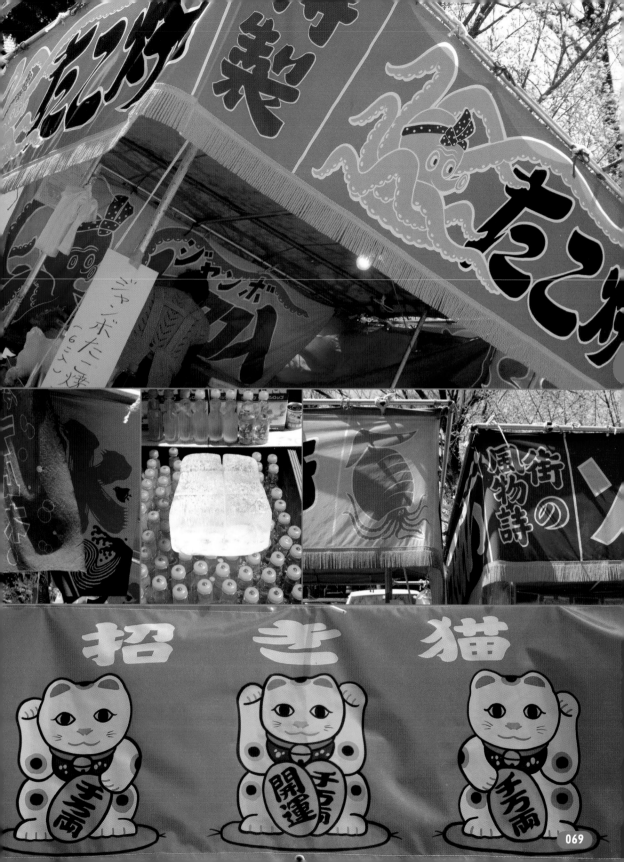

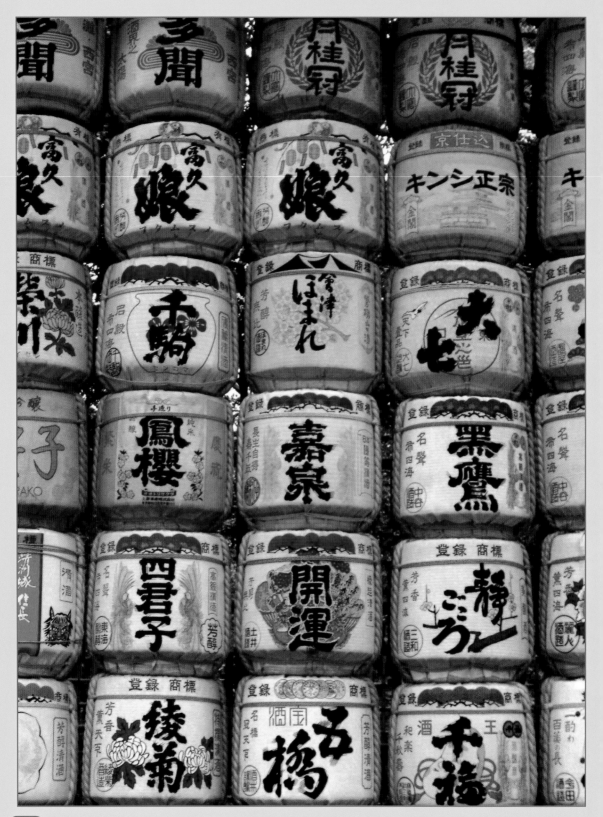

CAMPAI! Sake is as traditional an element of Japanese culture as you can get. Just like sacred grape juice in the West, fermented rice wine holds a consecrated spot in the heart of any aficionado of Japanese cuisine. Traditionally, sake is preserved in wooden casks, decorated either with the crests of the manufacturer or with classic and traditional markings such as pine trees, cranes, and Mt. Fuji. And there is always an alternative for the drinker on the go—sake from a vending machine.

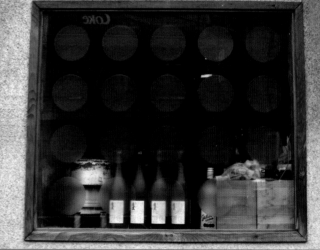

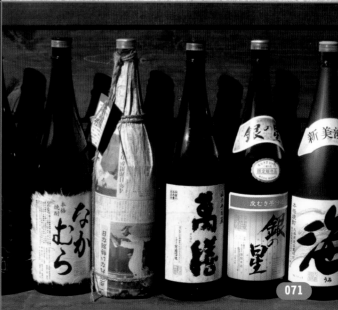

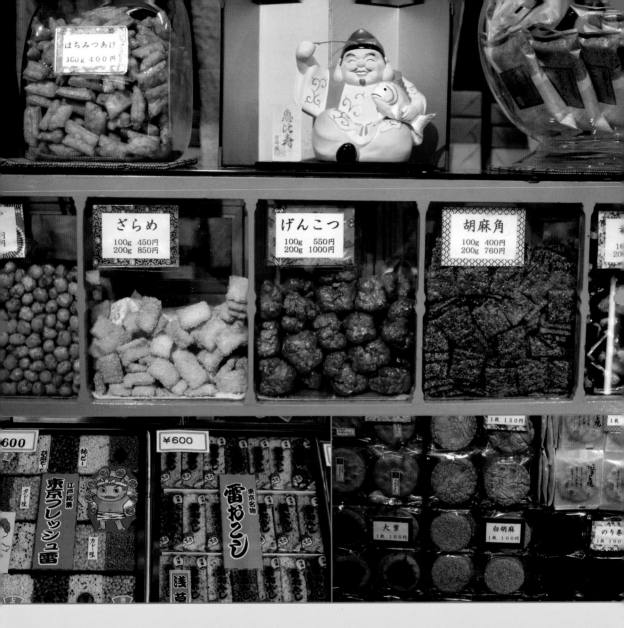

はちみつあげ
100ｇ ４００円

恵比寿

ざらめ
100ｇ 450円
200ｇ 850円

げんこつ
100ｇ 550円
200ｇ 1000円

胡麻角
100ｇ 400円
200ｇ 760円

￥600

東京フレッシュ雷

雷おこし

1枚 150円

大葉
1枚 100円

白胡麻
1枚 100円

のり巻
1枚 100円

SENBEI AND WAGASHI Japanese snack food may seem incredibly sweet or overwhelmingly salty if you're not used to it, but make no mistake, it is beautiful to look at. From the classic fish-shaped buns filled with sweet-bean paste (*taiyaki*) to an assortment of crunchy, seaweed-wrapped crackers (*senbei*), it is sure to draw you in. The geometry of Japanese snacks is unlike that of any others. Rice crackers are organized according to geometric principles as well as taste. Other snacks are molded into stylized organic forms: flower blossoms, fish, and other natural shapes. The most aestheticized of all are the delightful snacks prepared for a traditional tea ceremony. Shaped as flowers and fruits, wrapped in beautiful paper or served in a small bamboo container, each elegant offering should be carefully examined and appreciated before being washed down the hatch with the refreshingly bitter green tea.

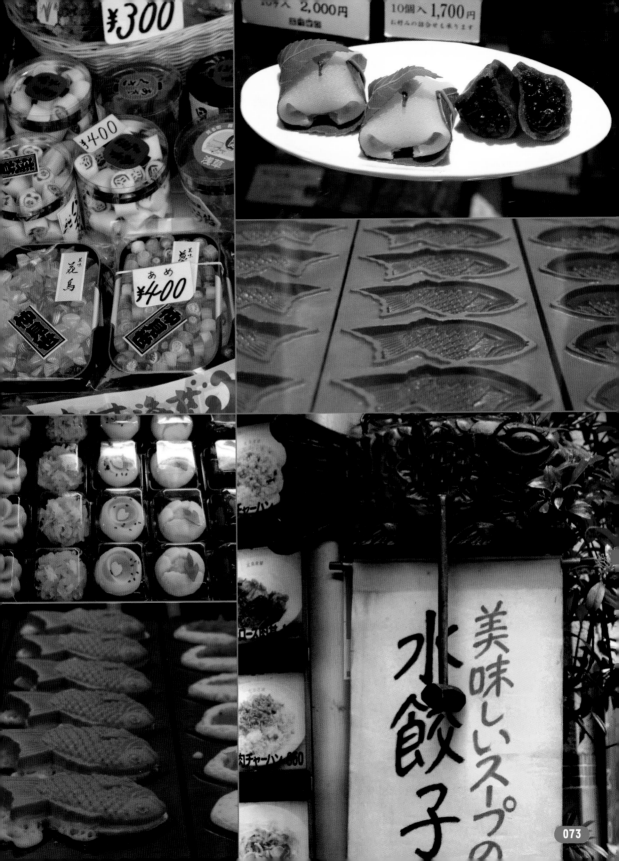

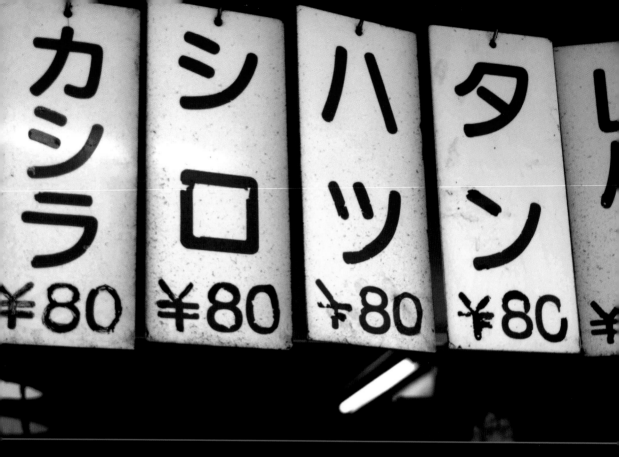

カシラ ¥80　シロ ¥80　ハツ ¥80　タン ¥80　レ ¥

たこ焼

¥500

¥700

自家製
いなり寿司
8個入
¥400

うめぼし・こんぶ・かつおぶし
おにぎり
三個入
¥450

たこ焼
¥40

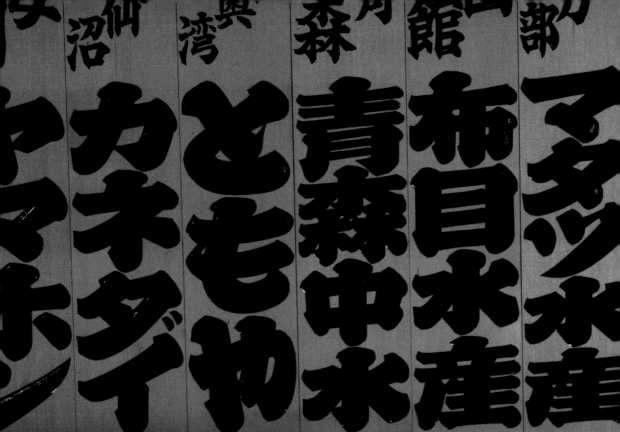

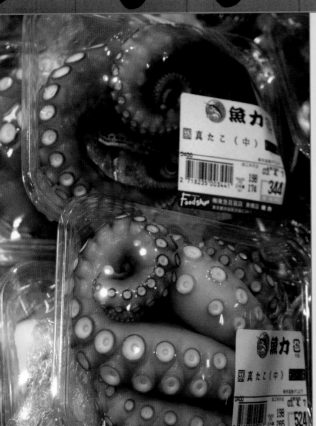

PRICING Customary for most eating establishments is the Japanese-style menu: a series of vertical and narrow wooden placards that are hung from small pegs in a row. These modular units allow the proprietors to update their menu depending on the catch of the day. Such placards can also be found in other venues like the fish shop (above), where they have been set in a fixed case. The origin of each fish is above the name of the catch. Thick strokes, showing the clear influence of the brush pen, are pretty much standard in such displays and hark back to pre-Edo stylization.

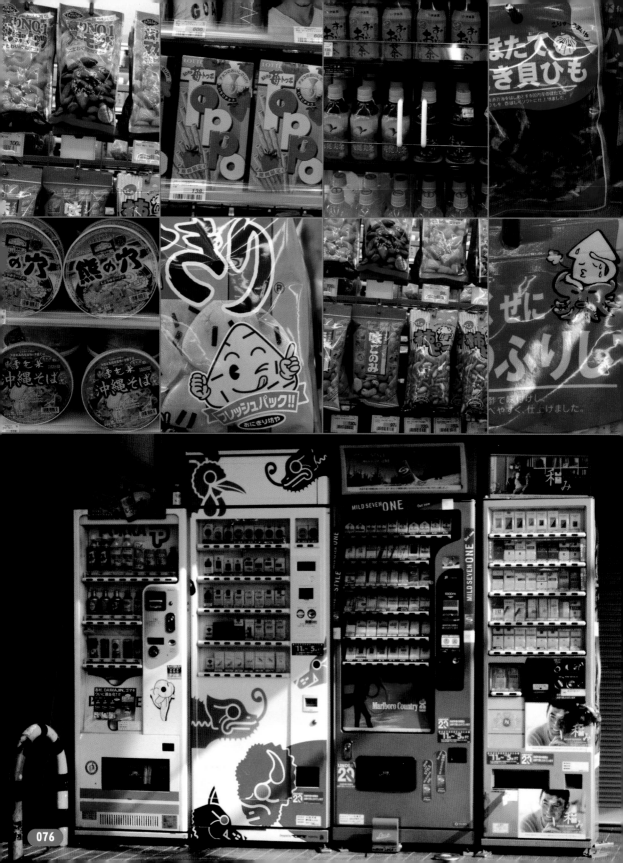

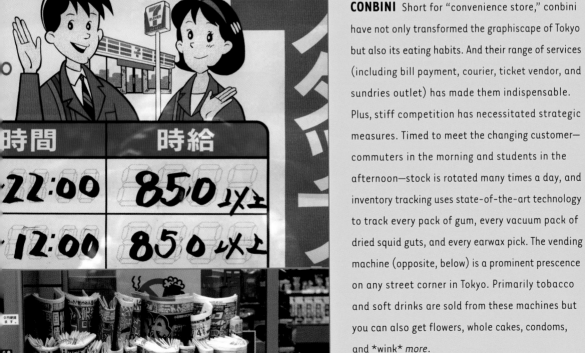

CONBINI Short for "convenience store," conbini have not only transformed the graphiscape of Tokyo but also its eating habits. And their range of services (including bill payment, courier, ticket vendor, and sundries outlet) has made them indispensable. Plus, stiff competition has necessitated strategic measures. Timed to meet the changing customer—commuters in the morning and students in the afternoon—stock is rotated many times a day, and inventory tracking uses state-of-the-art technology to track every pack of gum, every vacuum pack of dried squid guts, and every earwax pick. The vending machine (opposite, below) is a prominent prescence on any street corner in Tokyo. Primarily tobacco and soft drinks are sold from these machines but you can also get flowers, whole cakes, condoms, and *wink* more.

THE EMPIRE OF SIGNAGE

For a culture closely identified with refinement, rigidity, and simplicity, the barrage of information on Tokyo's streets is inescapable stimulation. While the appreciation of subtle differences is the hallmark of Japanese sensitivity, Tokyo can launch a veritable onslaught of details, presenting an endless variety of subtleties. The resulting effect is one of a complex cacophony—an organized chaos in decided and sharp contrast to the serene rows of finely raked sand found in traditional temple grounds. At first the two can seem conflicting opposites, but it is the continual oscillation between simplicity and complexity that contributes to Tokyo's charm yet can also make the city seem impenetrable.

A case in point is written Japanese. There is not just one writing system but three, or four if you count the unofficial official second language, English. Japanese was a solely spoken language until the adoption of Chinese characters, *Kanji*, during the Nara period (710–794). These discrete graphic elements convey meaning by functioning either as a pictograph or an ideograph. Each character has a multiplicity of possible readings (or phonetic equivalents) according to context and intended meaning. This writing system is supplemented by two syllabaries, *Hiragana* and *Katakana*, which are comparatively straightforward in function and form. Native Japanese phonetic writing systems, they function not unlike a standard alphabet. The intricate interrelation of these three systems is the basis for how the Japanese navigate the city's graphiscape as a whole. So varied, distinct, and perplexing is its system of nonverbal communication alone, it is veiled in mystery for the "outsider."

Another not unrelated vision of Tokyo is that of a glistening futurescape, a Mecca of advanced technology materialized in the here and now, illumined by giant TV screens, outrageous architectural shapes, and corresponding signage, thick with layers of neon advertising restaurants and clubs. This is altogether the case. At certain intersections the graphiscape is hypermodern and flickers temptingly with all sorts of stimulations to eat, buy, and mind your manners. Just as apparent, however, are the vestiges of traditional Edo, the ancient capital, or of fashionably mod 1920s Tokyo, abuzz with jazz and hostess bars, revived during the postwar recovery and economic boom. All these aesthetic modalities coexist in the contemporary Tokyo, whose population brings a sophisticated visual literacy to understand the delicate connotations rendered by slightest variations in style, color, and location. Navigating these signposts comes with practice. Until then, it remains self-contained, techno, and mysterious, swarming with electrons of connotation and code.

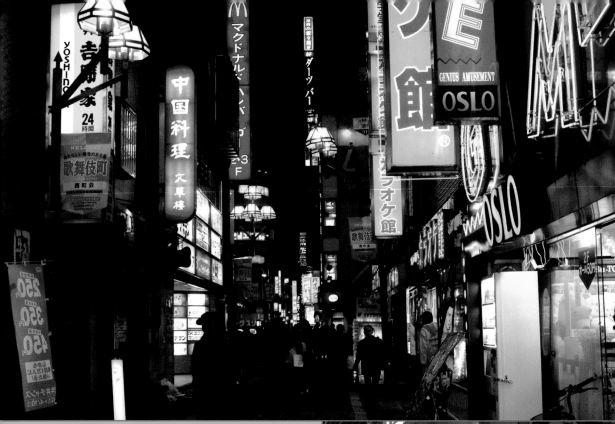

NEON SIGNS The night sky above Tokyo develops a special hue on cloudy evenings when the neon light that blankets it is directed back toward the city. The wattage of LCDs and the tons of neon gas that are expended in a single evening are immeasurable. The effect this creates is a soft, steady luminescence, giving the denizens of the night a special glow. There are a few city spots renowned for their agglomeration of neon, huge TV screens, and giant, glowing *kanji*: Shinjuku, Shibuya, Ginza, and Akihabara. The first three are contemporary pleasure quarters of sorts, packed with *pachinko* parlors and *karaoke* spots, hipster clubs and hostess bars. Akihabara is the odd one out, but glows equally bright as a center for the sale of electronic goods.

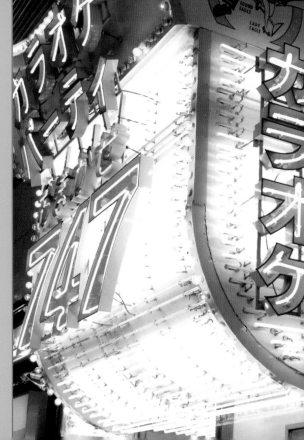

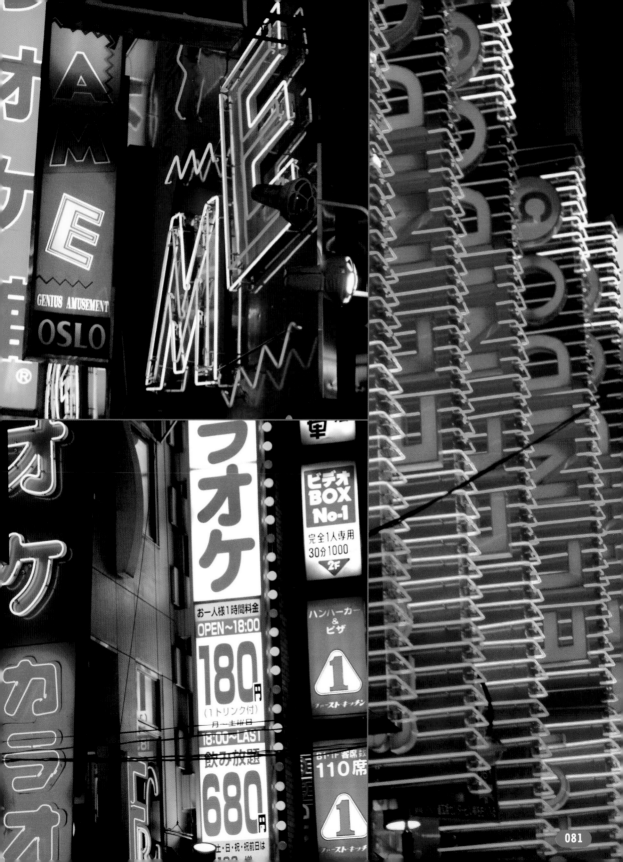

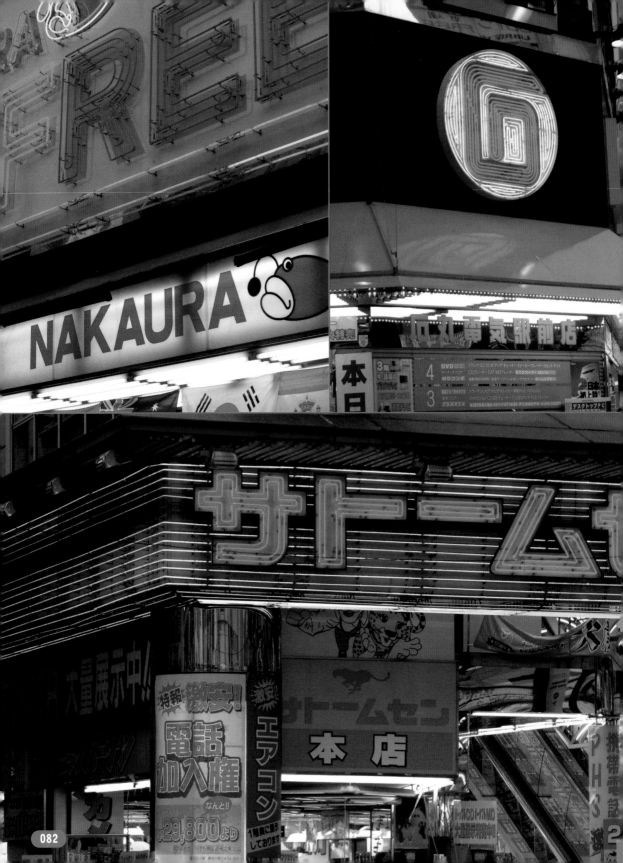

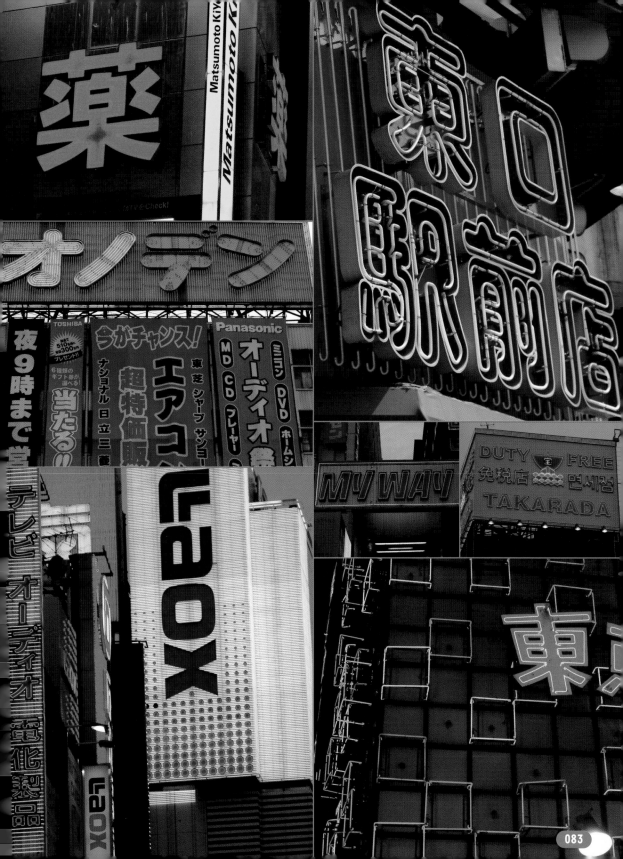

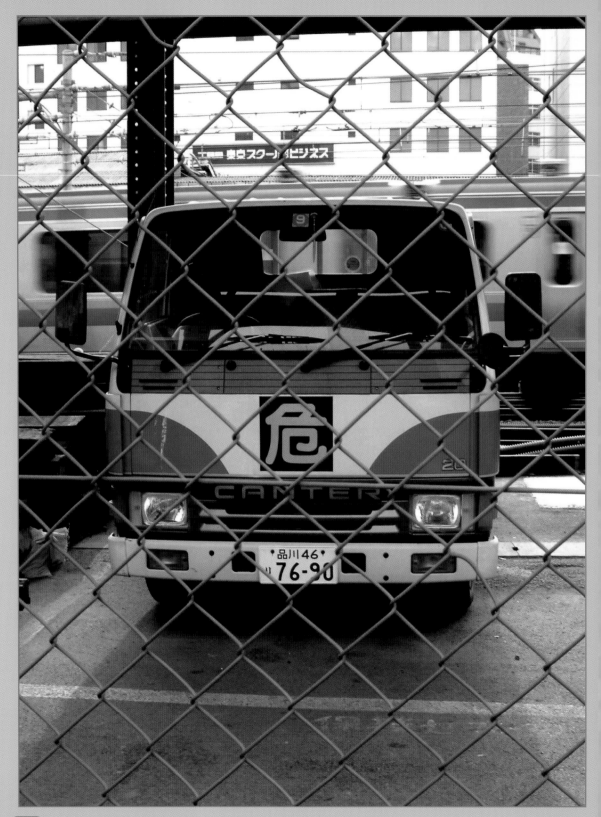

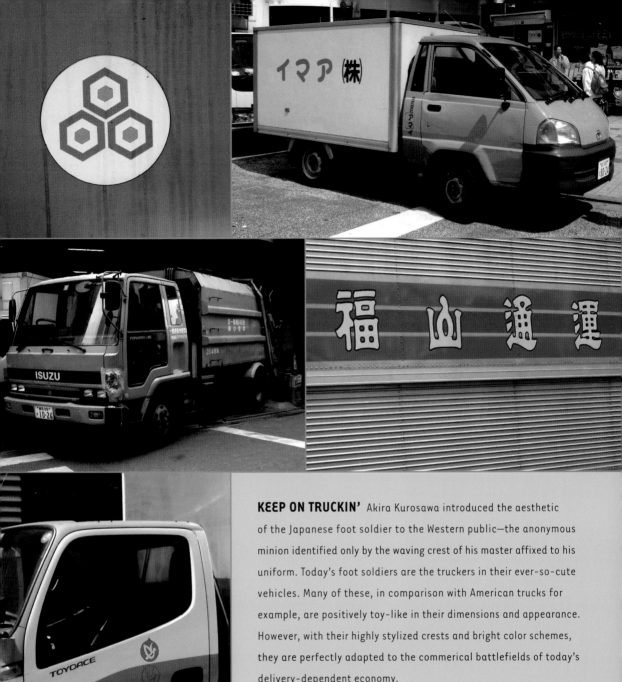

KEEP ON TRUCKIN' Akira Kurosawa introduced the aesthetic of the Japanese foot soldier to the Western public—the anonymous minion identified only by the waving crest of his master affixed to his uniform. Today's foot soldiers are the truckers in their ever-so-cute vehicles. Many of these, in comparison with American trucks for example, are positively toy-like in their dimensions and appearance. However, with their highly stylized crests and bright color schemes, they are perfectly adapted to the commerical battlefields of today's delivery-dependent economy.

KANJI Written Japanese is comprised of three systems, one of which is *kanji*. These are Chinese characters, either pictograms (representing an existing object), ideographs (graphic depictions of concepts and ideas), or a combination of the two. *Kanji* strokes are as intricate as its history is long. This makes for much ambiguity and, despite modern standardizations, there is a strong aesthetic for the beautifully warped characters that result from a brush pen. A single character should fit into a specified box, but with upward of 20 strokes for each, it would be impossible to cram all the elements together when writing by hand. The resulting graphic is (usually) beautifully lopsided and dynamic.

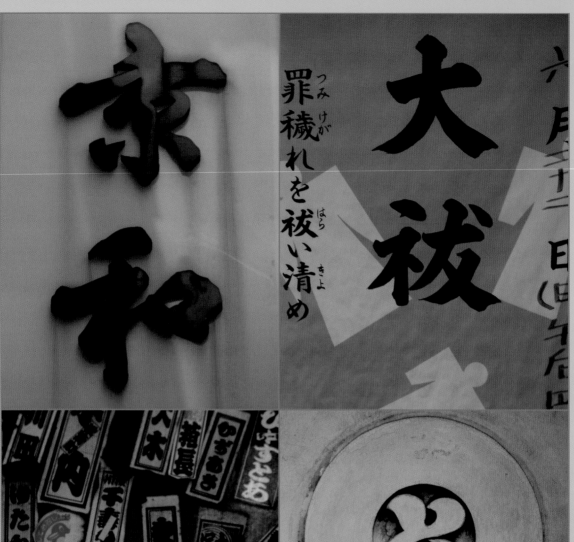

大祓

罪穢れを祓い清め

つみ けが

はら

きよ

六月三十二日（日）午后四

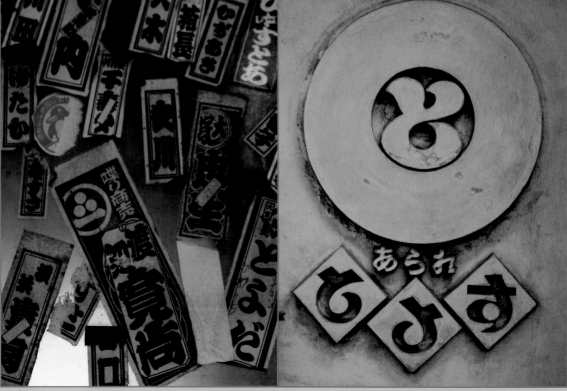

あられ

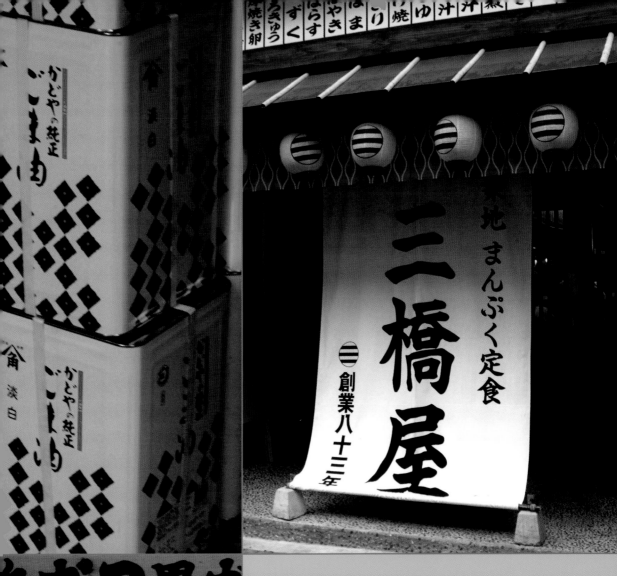

SIMPLICITY Simple is as simple does. At the reserved end of the Japanese graphic scale, simplicity is a highly esteemed aesthetic. Black ink against white paper; gray-on-gray in a single-palette sign; subtle shades of green and fundamental shapes. These elements are prized for their restraint and sophistication; a cleansed visual palette is required to appreciate them at their best. In such stark settings, each subtle shift in tone or line strength has all the more substance.

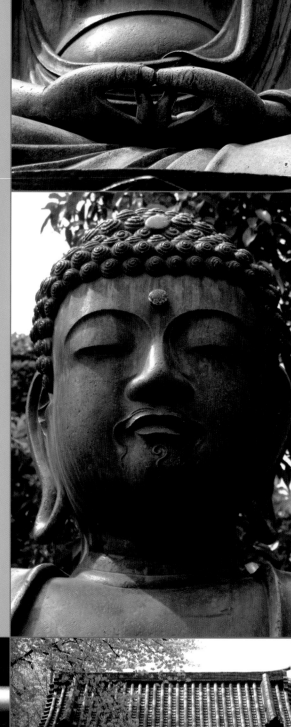

VOTIVE MARKS The two primary Japanese religions, Shintoism and Buddhism, are fairly content to hold equal sway in the public consciousness. Shintoism, the native Japanese religion, is animist. The name means, literally, "the way of the gods." Its shrines are discernable from the gate, or *torii*, marking their entrance. They are also distinguished by the many opportunities to have one's fortune told via the lottery-based *omikuji*. Whether you like your fortune or not, be sure to tie it around a tree or the bars provided for this purpose: in so doing, good fortune will come true and bad fortune will be averted. Shrines also sell votive offerings with illustrated panels. These panels are hung in public view, with individual inscriptions petitioning for luck in passing an exam or getting married, safe travels for a loved one, and other personal requests. Buddhist temples, in addition to the prerequisite graceful Buddhas, are more likely to feature a swastika, symbolizing good luck. These two symbols, the *torii* and the swastika, denote the location of a Shinto shrine or Buddhist temple on local maps. Other "interactive" graphic elements at religious sites include pilgrimage stickers, to commemorate a visit, or concertina papers hung from braided straw ropes (*shimenawa*).

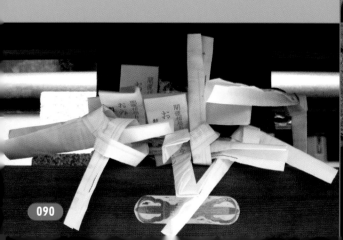

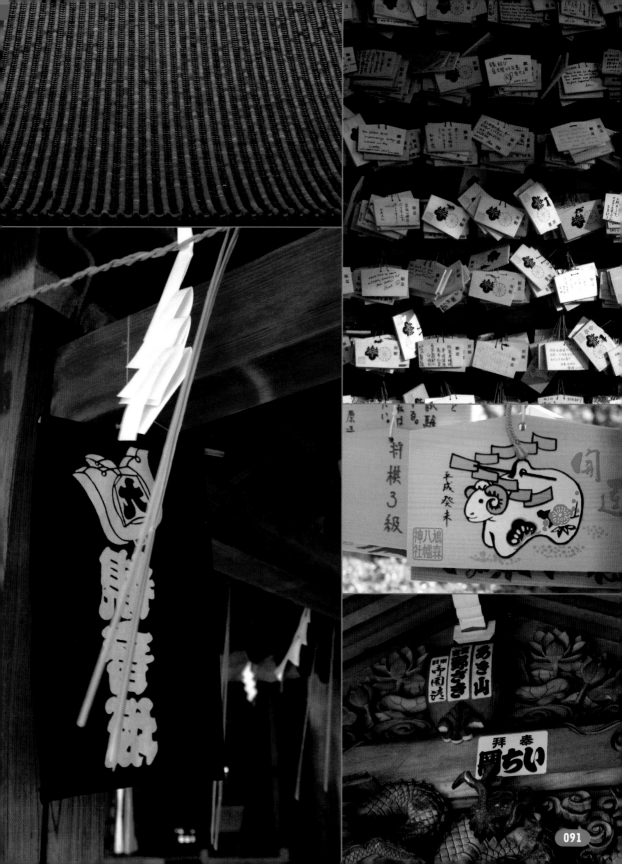

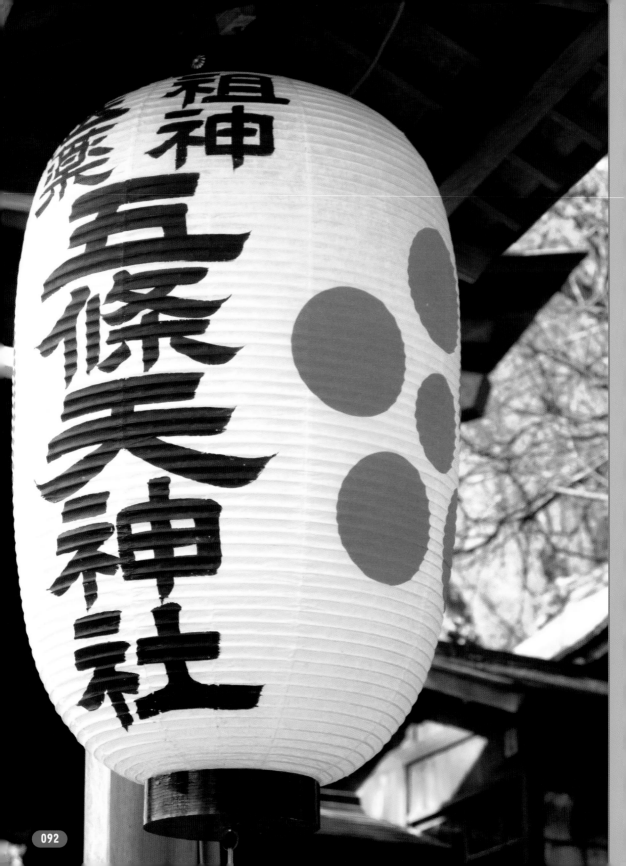

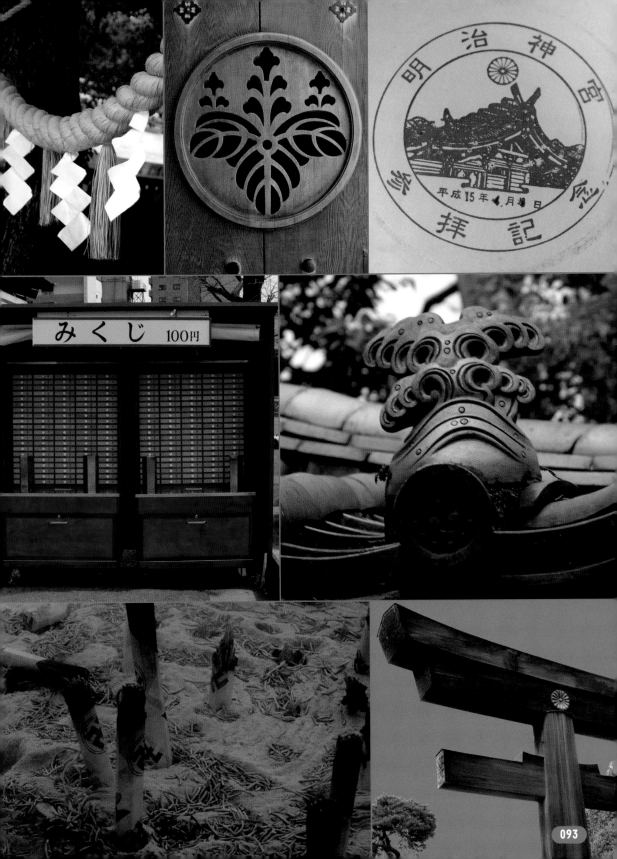

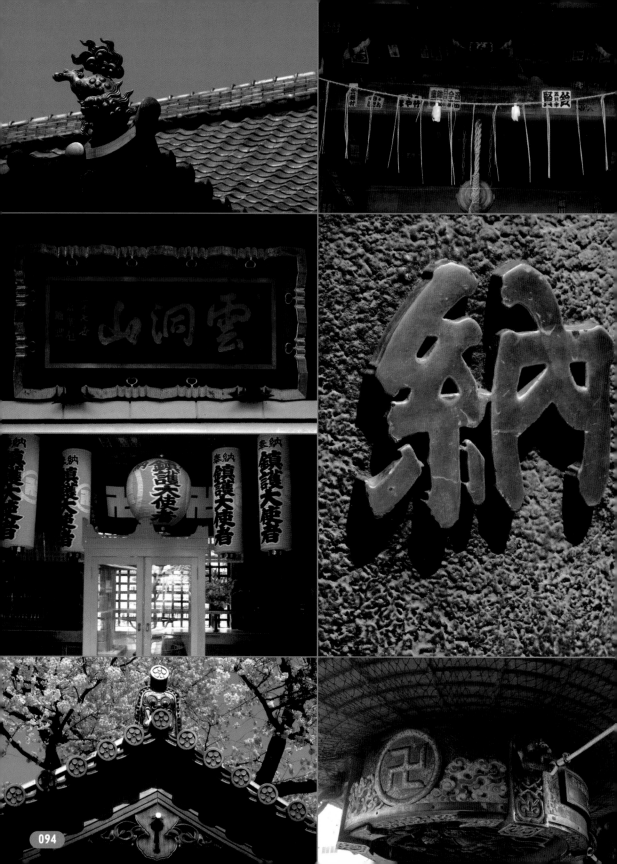

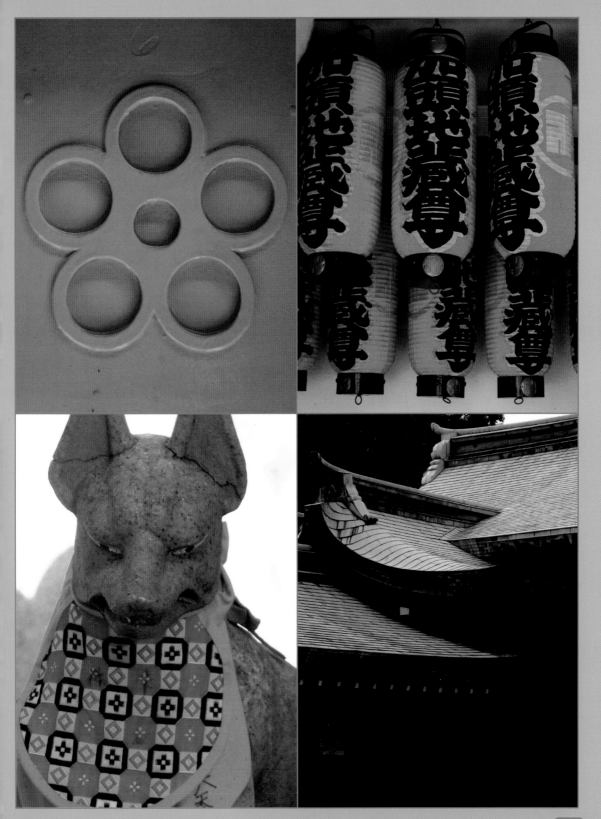

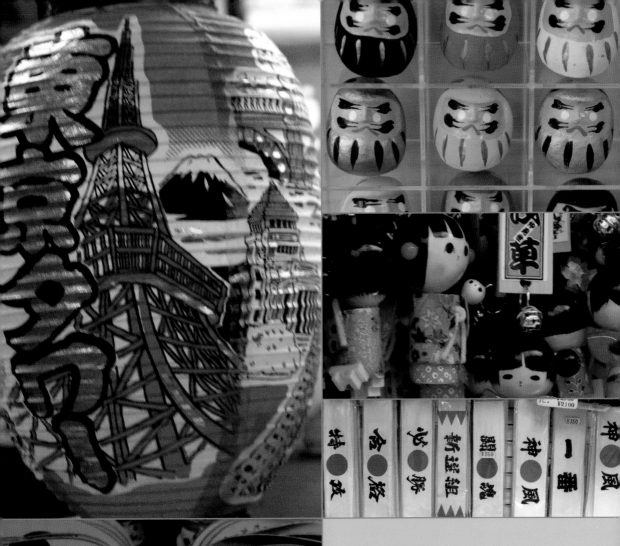

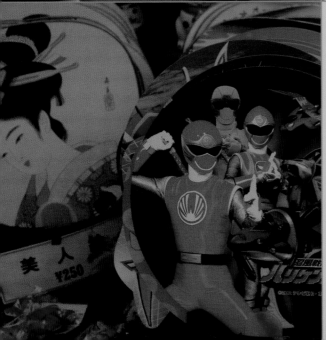

TACKY TOURISM Inevitably, no matter how sacred and serene the components of Japanese temples and shrines, the surrounding areas—particularly those of the more famous sacred spots—abound with tourist goods. The sale of amulets and votive panels segue without too much friction into sales of miniature lanterns, traditional crafts, and toys featuring the latest robot friend or Power Ranger.

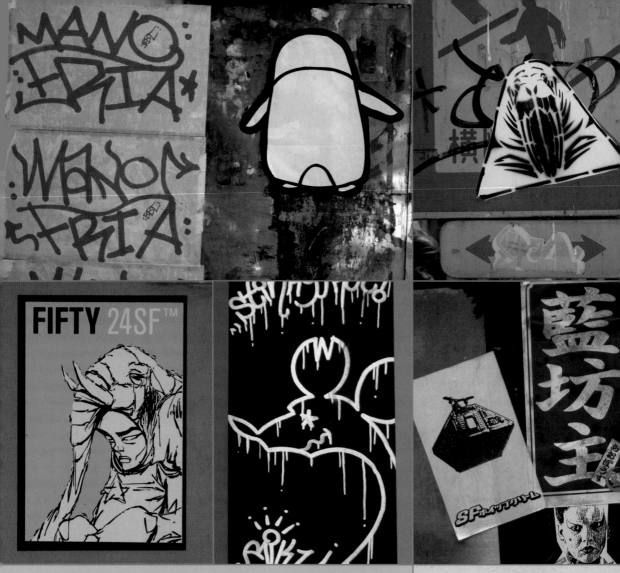

STUCK ON TOKYO Taking place in the nooks and crannies of Tokyo streets are a thousand tiny experiments in self-expression and personal brand creation. Who is behind each sticker? Be it slickly produced or prepared at home with a bubble-jet printer, each little sticker left on a local sidewalk or street sign is a small, personal advertisement for its creator. Who needs oil paint and struggle to secure an artistic reputation? These little staccato offerings can imbue a quick sketch with a powerful identity and fill the viewer with a need to find out just who ARE Epic and the other guys?

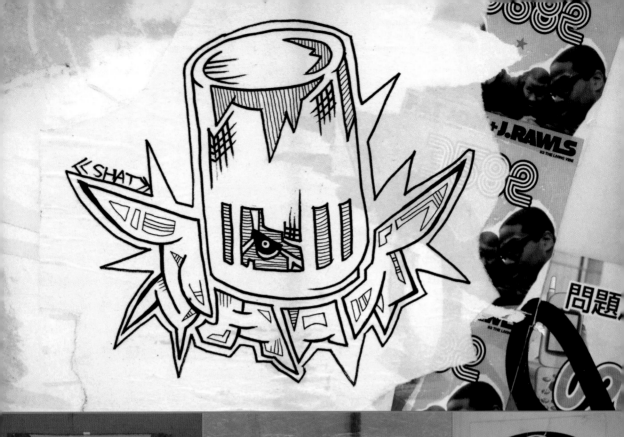

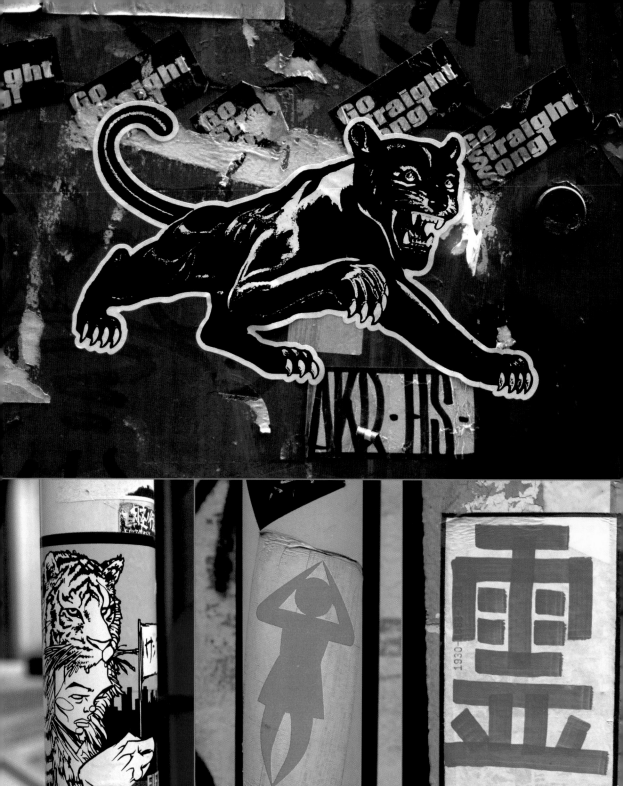

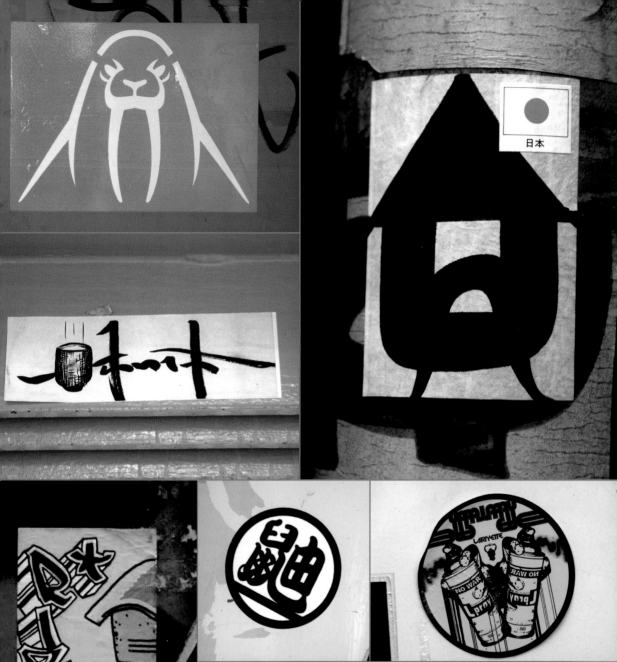

日本

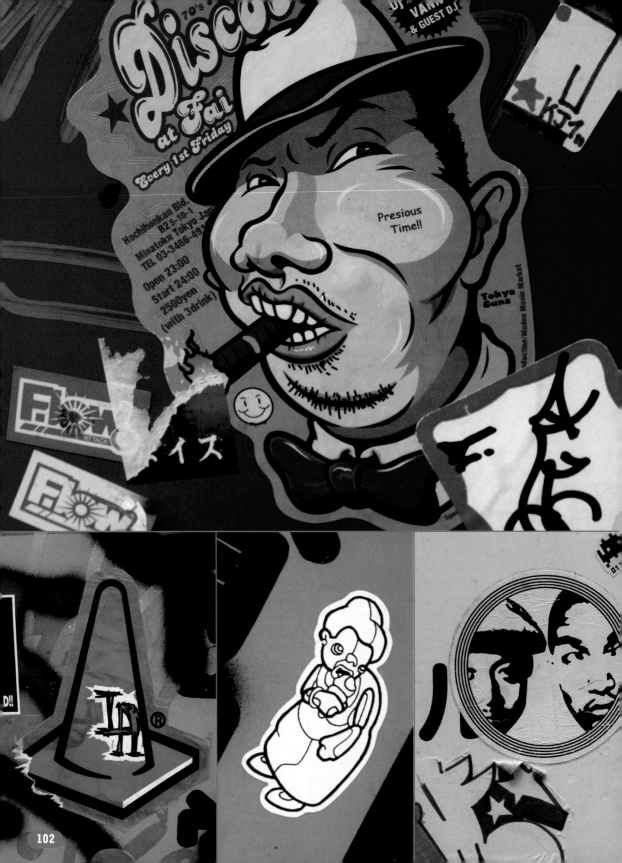

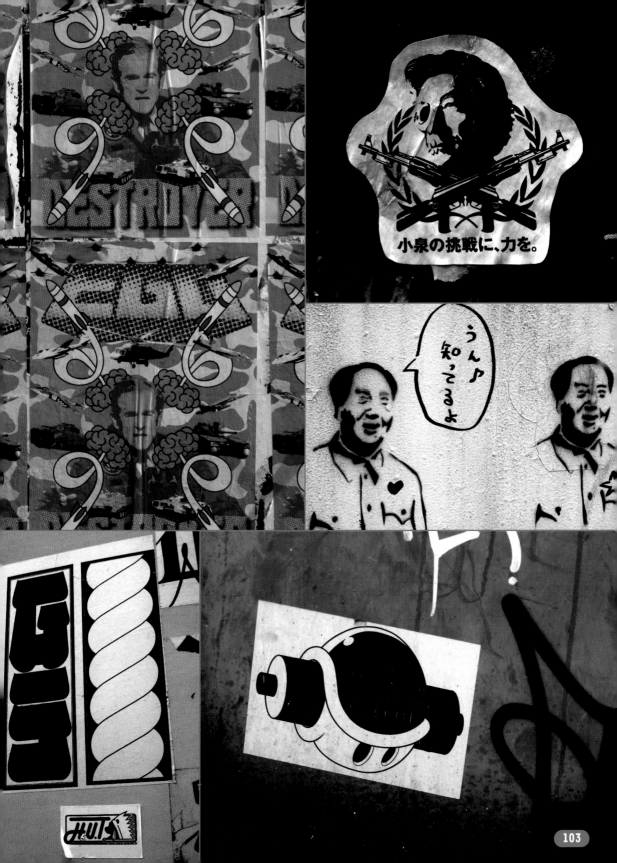

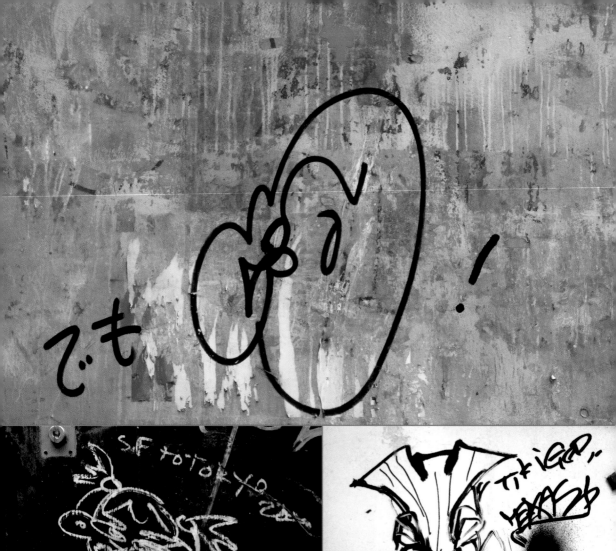

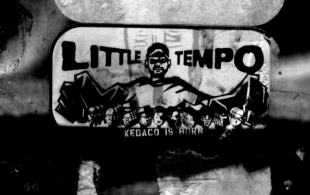

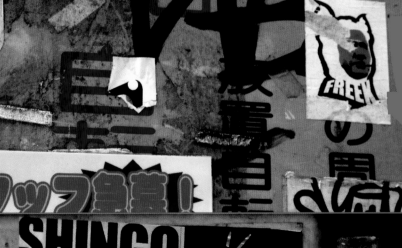

HYPER JOY

Work hard, play hard is a philosophy much adhered to in Tokyo, land of stimulation. After all, following a long day at the office, the three-hour commute to cram school, or an extended shopping adventure, what's a Tokyo-ite to do? There's no end of options, of course, with a thousand different temptations ranging from sports to gallery and museum hopping, amusement parks and *karaoke* halls to horse racing and mahjongg. One cultured response, of course, is to go to the theater. From *Kabuki* to *Noh* to *Takarazuka*, the all-female performance troupe specializing in melodramatic bodice-rippers, there are plenty of opportunities for entertainment. Posters advertising the latest hits of the season can be spotted throughout the city, but especially in the theater districts of Yurakucho, Shinjuku, and Asakusa. Except in the hands of masters such as the late Ikko Tanaka, the aesthetics of theatrical posters have changed no more than the actual story lines of the material performed. They feature the cast of characters pouting, grimacing, or smiling sweetly depending on the demands of the role.

However, if it's a more contemporary mode of entertainment you're in search of, there's always the local game center or *pachinko* parlor, found on every street corner and in clumps surrounding major train stations. In brilliant colors, their exteriors gleefully advertise the latest game hit and promise hours of high scores and superb new graphic treats. The *pachinko* parlors are full of die-hards blinking through the secondhand smoke at the bouncing ball bearings. A slightly younger scene, but no less intense, gathers at the game centers. The world of video games has become a billion-dollar industry, with Japan's top companies, such as Sony, Nintendo, and Bandai, ruling the roost. There's no question that this aspect of Japanese pop culture (along with *manga* and *anime*) has become very much a part of international youth culture; the characters from *Street Fighter* and other now classic video games have become known worldwide. And just as the early film industry in the US established a handful of classic narrative genres, so too has the world of video games helped shape interactive storytelling genres, from "adult-lad" games involving rounds of fighting between now-beloved and well-established characters, to the classic quest games of *Sonic the Hedgehog* and even *PacMan*. To adolescents and young adults worldwide, these genres mean as much, if not more than the now forgotten fairy-tale classics.

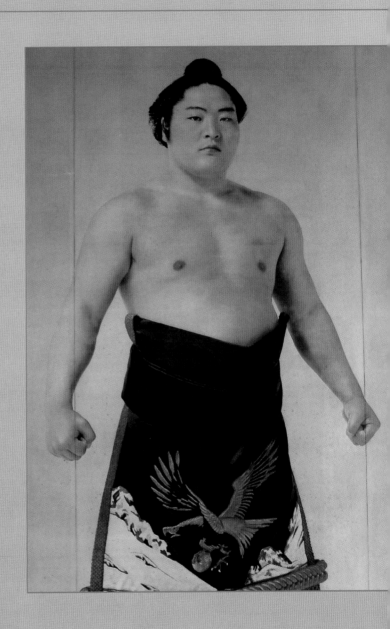

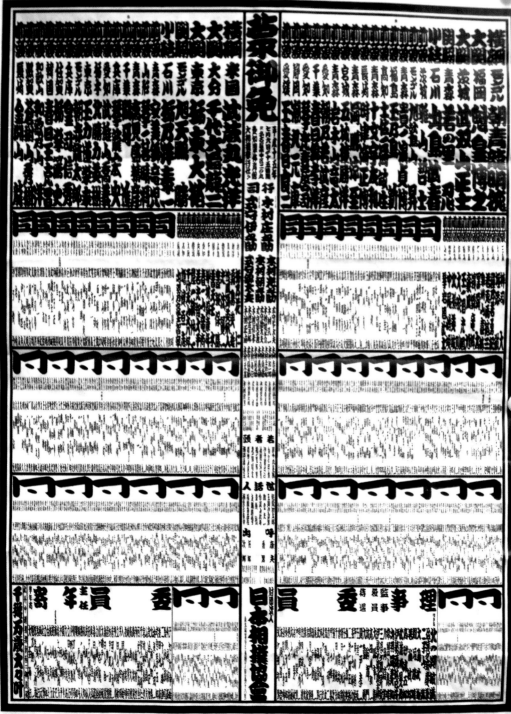

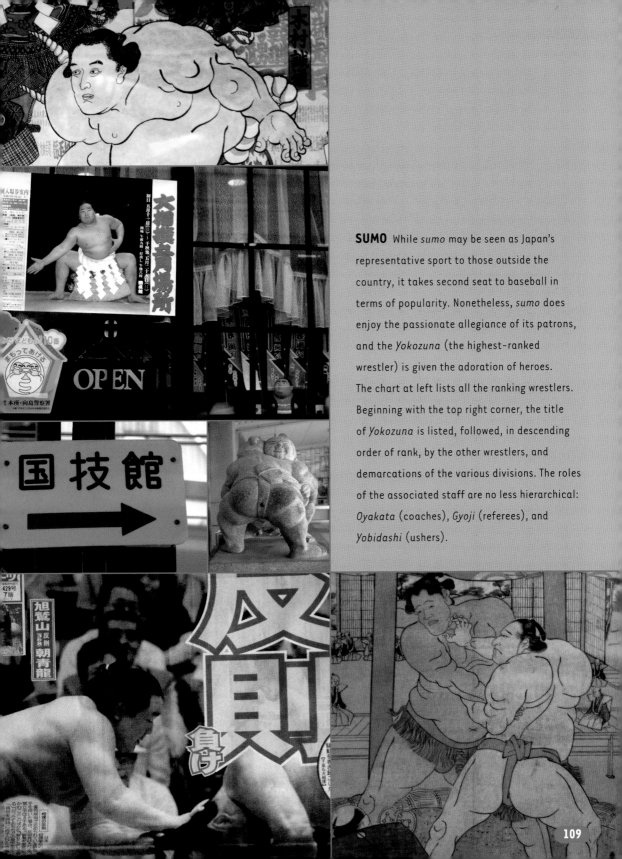

SUMO While *sumo* may be seen as Japan's representative sport to those outside the country, it takes second seat to baseball in terms of popularity. Nonetheless, *sumo* does enjoy the passionate allegiance of its patrons, and the *Yokozuna* (the highest-ranked wrestler) is given the adoration of heroes. The chart at left lists all the ranking wrestlers. Beginning with the top right corner, the title of *Yokozuna* is listed, followed, in descending order of rank, by the other wrestlers, and demarcations of the various divisions. The roles of the associated staff are no less hierarchical: *Oyakata* (coaches), *Gyoji* (referees), and *Yobidashi* (ushers).

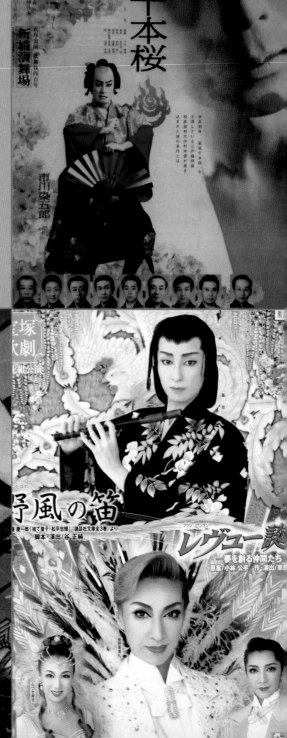

THEATRICAL POSTERS For directors and producers pushed to the end of their ropé by egotistical actors, *Bunraku* is the solution. This is a theater production of puppets and one of many theatrical and stage traditions in Japan, including *Kabuki*, *Noh*, *Rakugo*, and *Odori*. In addition to comparatively recent imports, like musicals and modern plays, there is the thoroughly Japanese *Takarazuka*—an all-female cast staging productions covering every genre that theater has ever known.

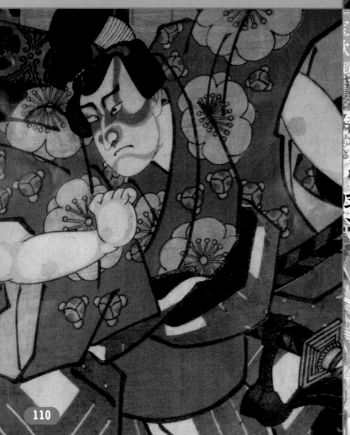

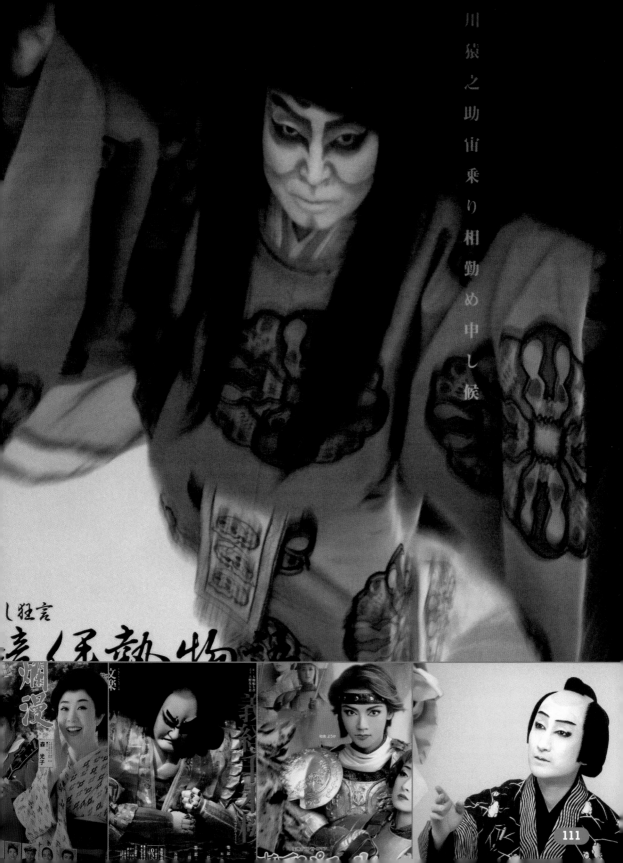

川猿之助宙乗り相勤め申し候

し狂言

NEO-SHUNGA There is a healthy tradition of erotic art in Japan, reaching back to the *ukiyoe* (woodblock prints) of the Edo period (1603–1687). Though the scenes depicted in ukiyoe were generally of everyday life, their erotic counterparts, known as *shunga*, were far from ordinary depictions. After all, large penises drawn with such an elaborate degree of exaggeration were products of the imagination, one hopes. This work was the progenitor of the continued and ever-expanding arena of erotic art, which is continued in certain genres of *anime* and *manga*. It also defined the graphics that are associated with the sex industry in Japan, although these days one is much more likely to see renderings of childlike girls with huge, doe eyes, than the object of their fixation. (By the way, *manzoku* means satisfaction.)

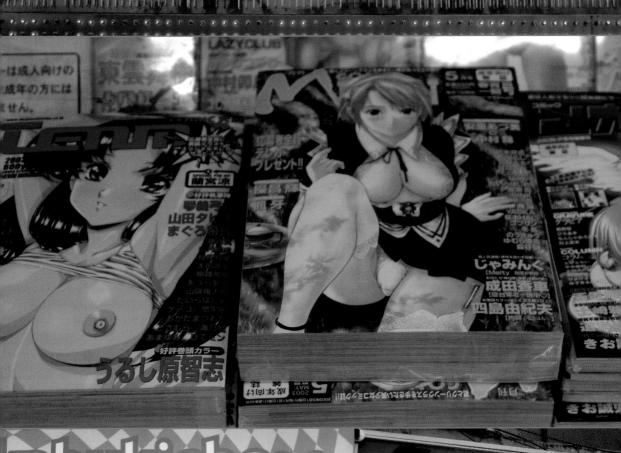

113

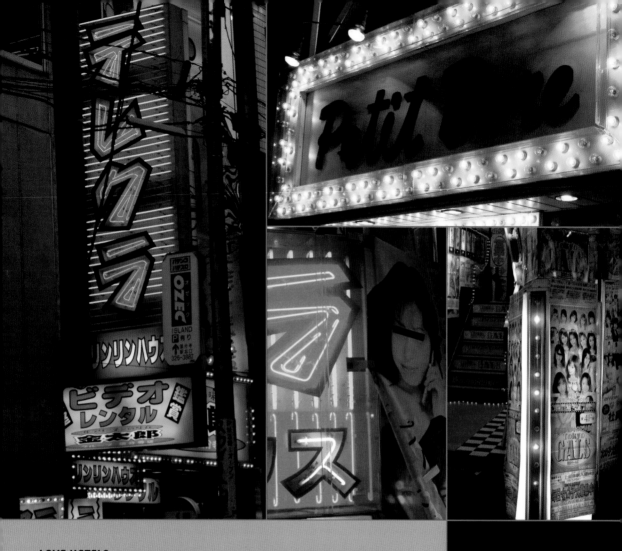

LOVE HOTELS Cramped conditions and little privacy would make furtive forays an impossibility were it not for the "love hotel"—a hotel used specifically for you-know-what. The rates are prominently displayed outside: "Rest" (usually about two hours of room rental) or "Stay" (an overnighter). So advanced is the setup, even the most clandestine of lovers can "rest" assured. In most places there is no front desk and you pay the bill by feeding money into something that looks like a vending machine. Frequently, rooms are assigned themes, from "classic" *tatami* rooms to those with outer-space and Western motifs. The pricier the room the more "amenities" are at your disposal—and that includes almost everything from adult movies to bedside swimming pools.

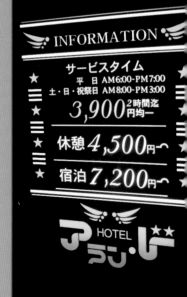

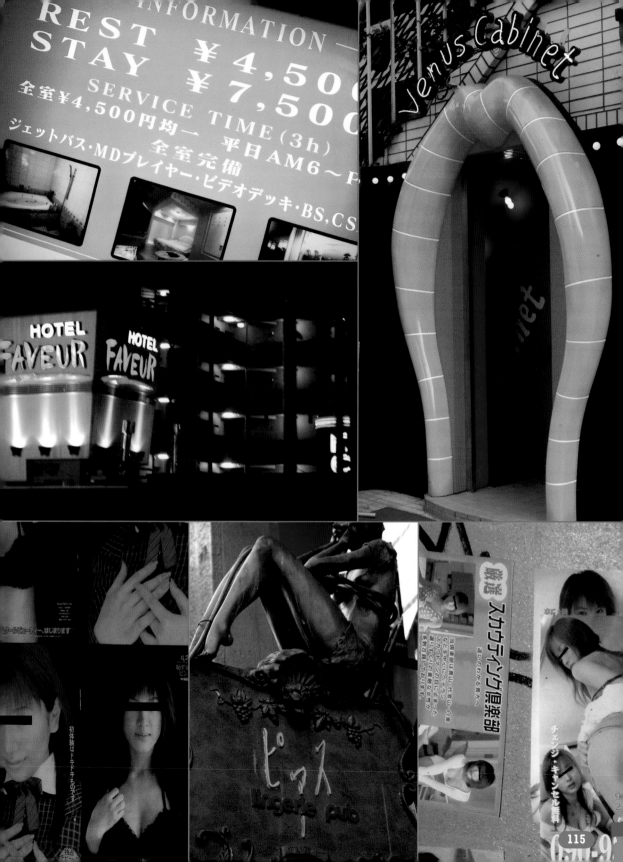

INFORMATION

REST ¥4,500
STAY ¥7,500

SERVICE TIME (3h)
全室¥4,500円均一　平日AM6〜P
全室完備
ジェットバス・MDプレイヤー・ビデオデッキ・BS,CS

Venus Cabinet

HOTEL FAVEUR

スカウティング倶楽部
厳選

チェンジ・キャンセル無料

115

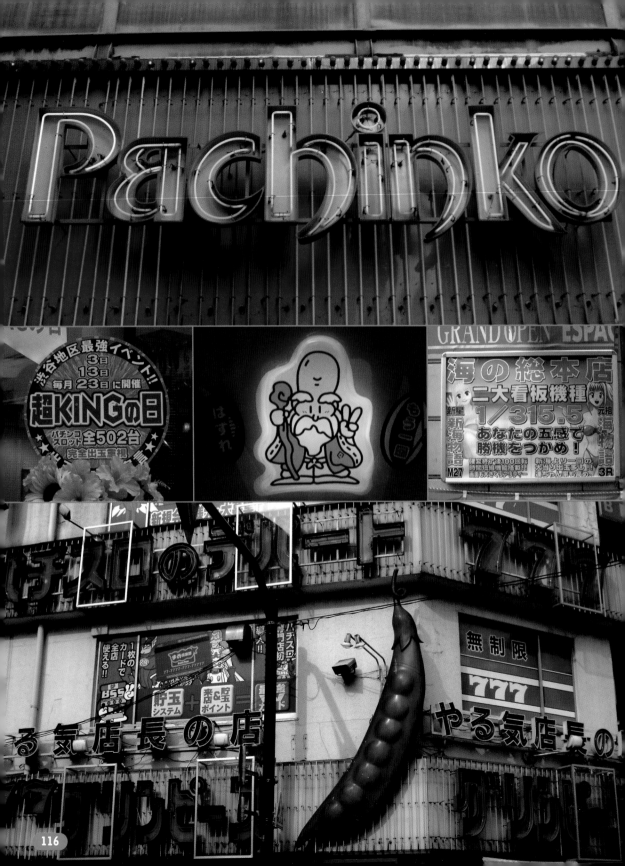

PACHINKO National pastime or bad habit? *Pachinko* is a mild form of gambling that has been around since the 1920s. The word comes from the onomatopoeic *pach-pachi*. Found in every part of Japan, the *pachinko* parlor has all the glitz (but none of the glamour) of Las Vegas. The console resembles an upright pinball machine, with countless metal balls moving through a matrix of obstacles. High scores yield buckets of balls that are redeemable for prizes and even cash. You can play for boxes of candy, watches, soft toys, or even use a robotic arm to try to catch live fish or crab. Each console also has its own theme, mostly taken from popular movies or cultural icons. With battery upon battery of consoles lined up, and each producing its own racket, it's easy to slip into a bit of a time warp. Seasoned players can spend hours on end locked to a machine. When machines are replaced, prominent banners announcing the event are displayed, producing lines of people waiting for the 10 A.M. opening hour. Make no mistake, this game is taken seriously. There are even professional pachinko players. You can read their stories, serialized in one of several magazines devoted to the game.

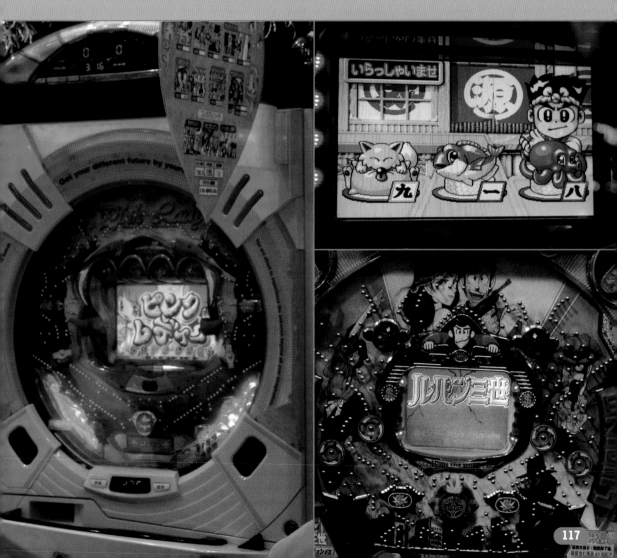

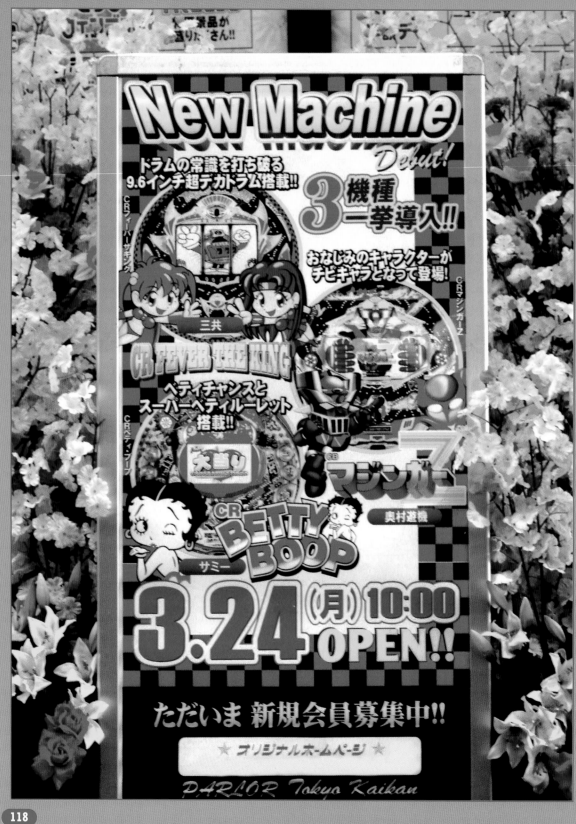

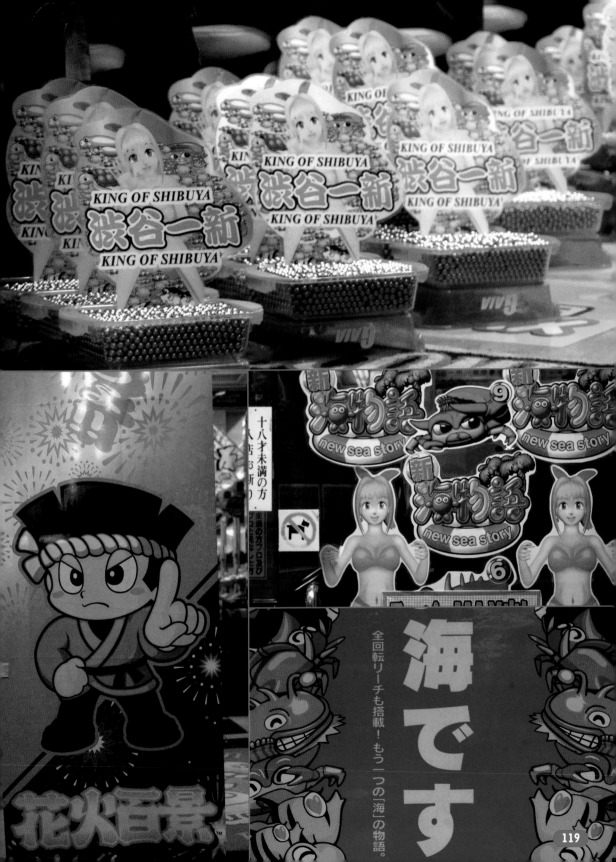

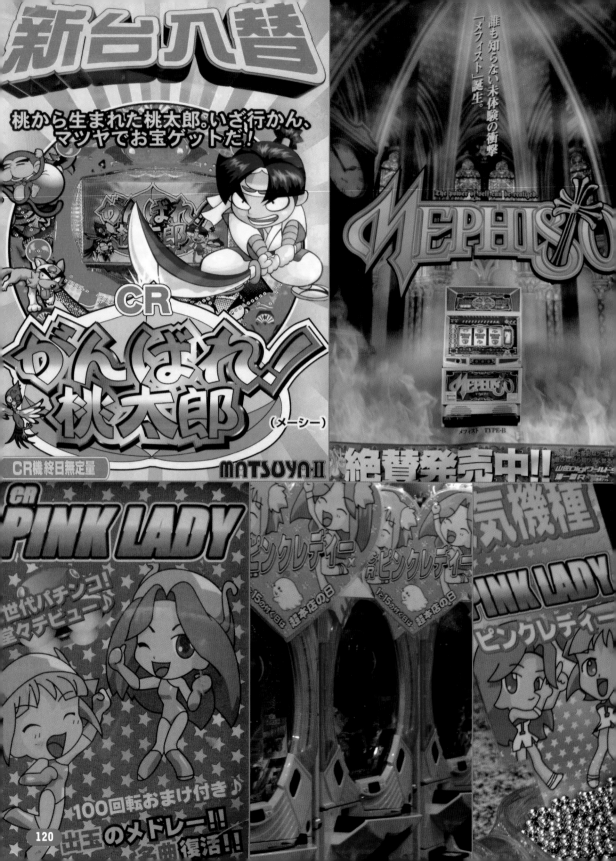

新台入替

桃から生まれた桃太郎。いざ行かん、マツヤでお宝ゲットだ!

CR がんばれ!桃太郎

（メーシー）

CR機終日無定量

MATSOYA-II

誰も知らない未体験の衝撃
「メフィスト」誕生。

The power of self can be realized.

MEPHISTO

メフィスト TYPE-B

絶賛発売中!!

CR PINK LADY

世代パチンコ!
室々デビュー♪

100回転おまけ付き♪
出玉のメドレー!!
名曲復活!!

ピンクレディー × R ピンクレディー
1・15のつく日は 超本店の日

気機種

PINK LADY
ピンクレディー

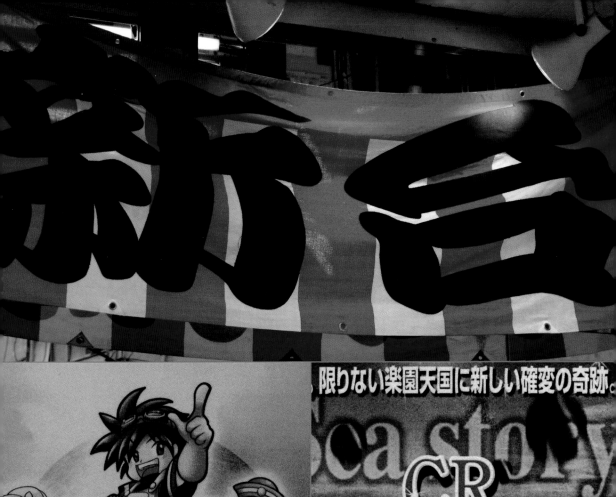

新台

限りない楽園天国に新しい確変の奇跡。

ea story

CR海物語3

100 New Miracle 回の奇跡

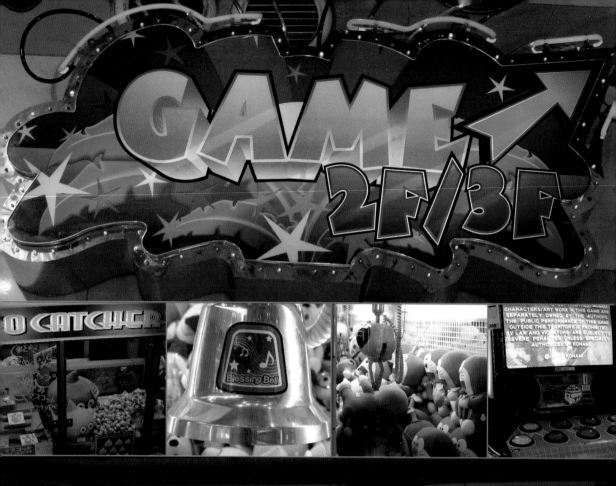

GAME 2F/3F

O CATCHER

Blossing Bell

HI-TECH LAND PENGUIN

playmax

GAME CENTERS It is no secret that Japan has an incredibly sophisticated gaming culture. From your classic shoot 'em up to complicated history and strategy games, from a million-and-one variations on *Tetris* to drumming, dancing, record-spinning games, there are countless ways of enticing adolescents and young salarymen to spend time dropping 100-yen coins into these machines. Japanese game centers continue to be a central gathering point for young adults. Here, in addition to the usual game consoles, you can get your nails painted, take a self-portrait in any number of sticker cams, or engage in heated dance competitions. And when you tire of playing for the honor of a high score, there's always the UFO CATCHER, a generic name for the wide variety of machines that allow you to steer a metal claw towards some fuzzy, cute toy waiting to be caught.

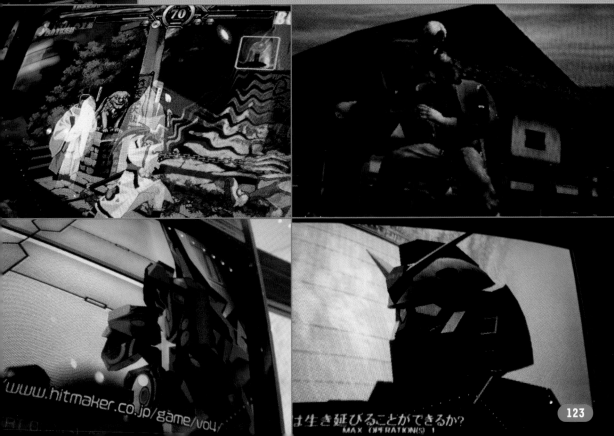

KARAOKE Is there an echo in here? The stereotype of Japanese obsessed with *karaoke* has a basis in truth. It can almost be considered a national pastime. *Karaoke-kan* (*karaoke* centers) are apparent in every corner of the country! Apparent too, are their garish neon signs, touting the recent advances in *karaoke* technology; the console can now measure your "output." A lackluster "YMCA" will score you only 4.5 kilocalories. So, don't sit back and relax while your friend scores 13 kcals on a heartfelt *enka* (Japanese ballad). Following the bouncing ball has never been so competitive!

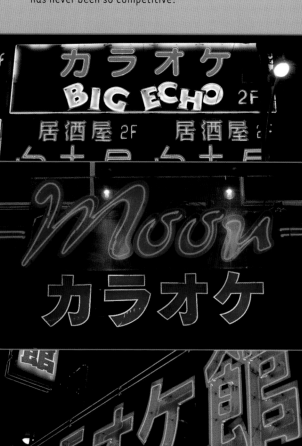

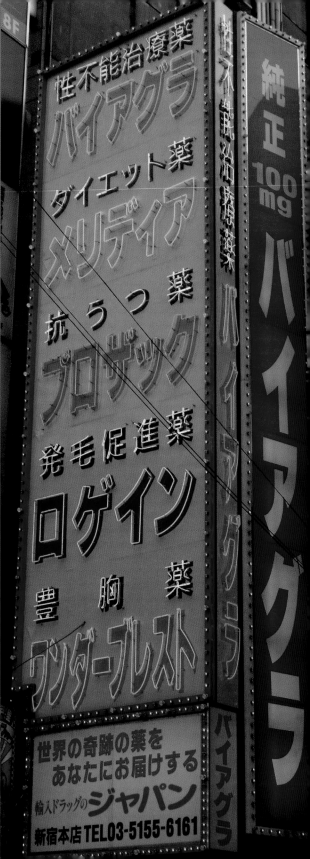

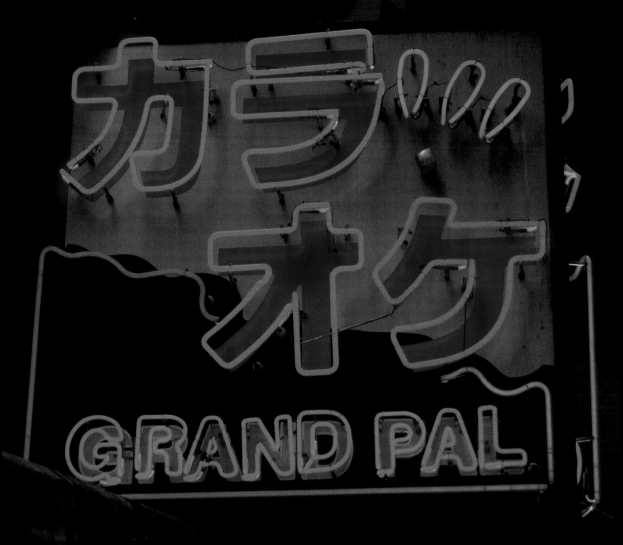

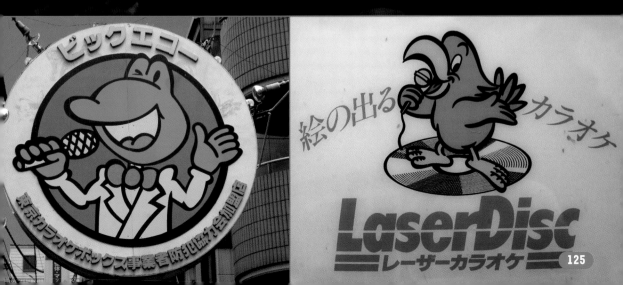

BOWING-RELATED ACCIDENTS For all the craziness that is compacted into its narrow and twisting streets, courtesy remains an uncompromised bastion of Tokyo culture. Nearly all doors are sliding and mechanized, not just for convenience and as a courtesy to the customer, but also because there is no space for a door to swing open. Shop customers are always welcomed by staff with a robust *irashaimase*. It seems, though, that there is little space for common courtesy. Every year there are reports of people being knocked off escalators and train platforms by an overenthusiastic bow. On the streets, the full-fledged bow has been replaced by the half bow as, invariably, there are people whizzing by who'd be bumped off track otherwise. Even if courtesy needs some abbreviation, the rigors of social contact are still intact. Not to infer that this is a strait-laced society, it's just that there are clear boundaries governing when certain protocol is required, and when caution can be thrown to the wind with reckless abandon. (Hopefully, you're not in the way.) Wound up like a tight kimono during the day, shuffling to work with almost drone-like oblivion, office workers do have the night as an opportunity for release. And release they do! It is thanks to my former Japanese boss that I had some of the most brilliant hangovers. But, sure enough, we were there next day at the office, bleary-eyed and ready to get down to business as if nothing had happened. As if, just a few short hours before, the entire staff had not been falling over one another like a pile of limp, stuffed animals. Or perhaps I was simply too drunk to remember what actually happened. Either way, it was back to bowing my head while on the phone, sucking on a throat lozenge, and wishing I hadn't done *Hard Day's Night* as my closing number at the *karaoke-kan* the night before.

東京

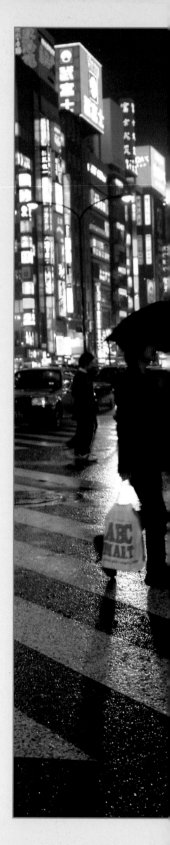

ACKNOWLEDGMENTS The preparation of this volume would not have been possible without the gracious collaboration of our dedicated publisher Aidan Walker. Also at RotoVision, we'd like to thank Erica Ffrench, who provided invaluable editorial input in the book's first stage of formation. Lindy Dunlop also helped us to put our text in order. Rico Komanoya and April McCroskie shepherded this volume to completion. And RotoVision's Art Director, Luke Herriott, who helped us be confident with our layouts.

Next, there were several individuals whose assistance helped iron out so many of the technical difficulties that cropped up along the way, or provided encouragement: J. Walter Hawkes, Merideth Harte and the lovely ladies at 27.12 design, Cynthia and Hiroshi Kagoshima, Wendy and Tom Byrne, Aida Vartanian, the extended Martin family, S. Kwon, Valerie Koehn, Eric A. Clauson, Kyoko Wada, Suzannah Tartan, Caleb Hunt, Raphael Hunt, Todd Londagin, Michael Lorenzini and Nelia Vishnevsky, Gaudericq Robilliard, Stephen Morrissey and Johnny Marr, and to everyone else who pointed out a sign or a graffito, offered their help, or patiently listened and looked at our work in progress. Thanks especially to the unknown and unsung artists, graphic designers, sign painters, et cetera, et cetera, whose work is included anonymously and *in situ*, as it was originally placed, and how it was intended to be experienced.